INTRODUCING KYOTO

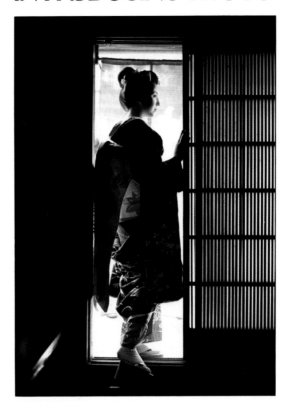

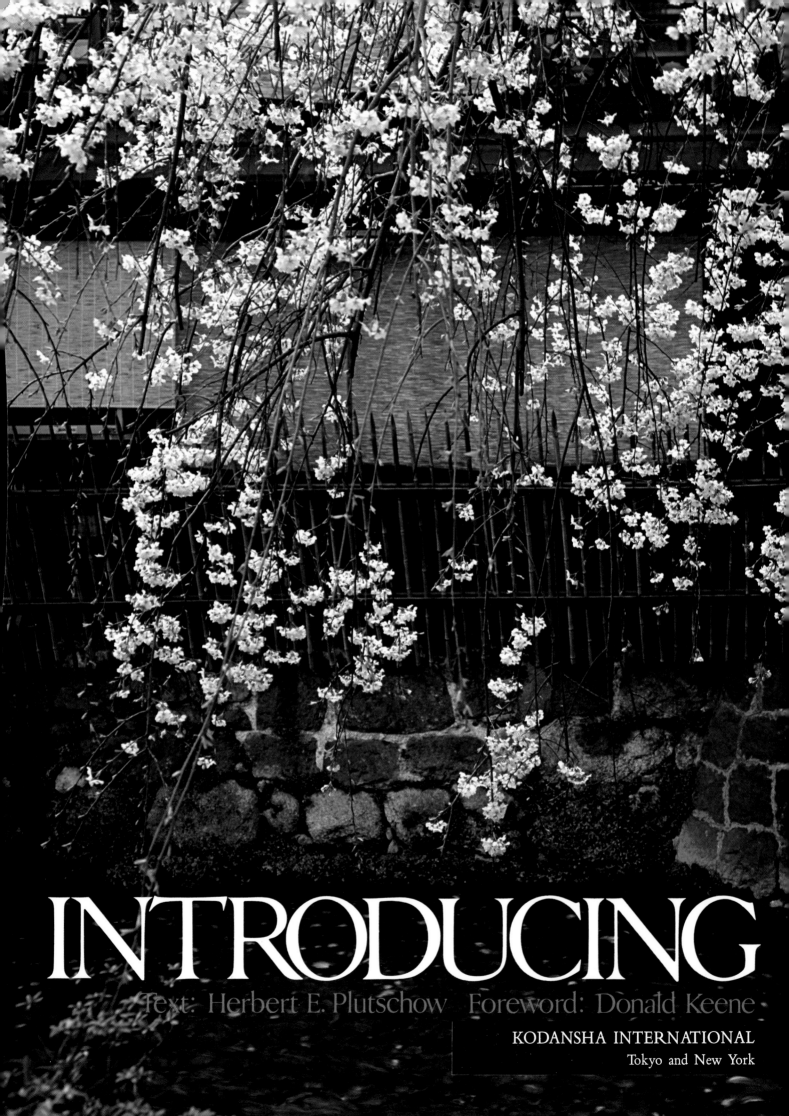

INTRODUCING

Text: Herbert E. Plutschow Foreword: Donald Keene

KODANSHA INTERNATIONAL

Tokyo and New York

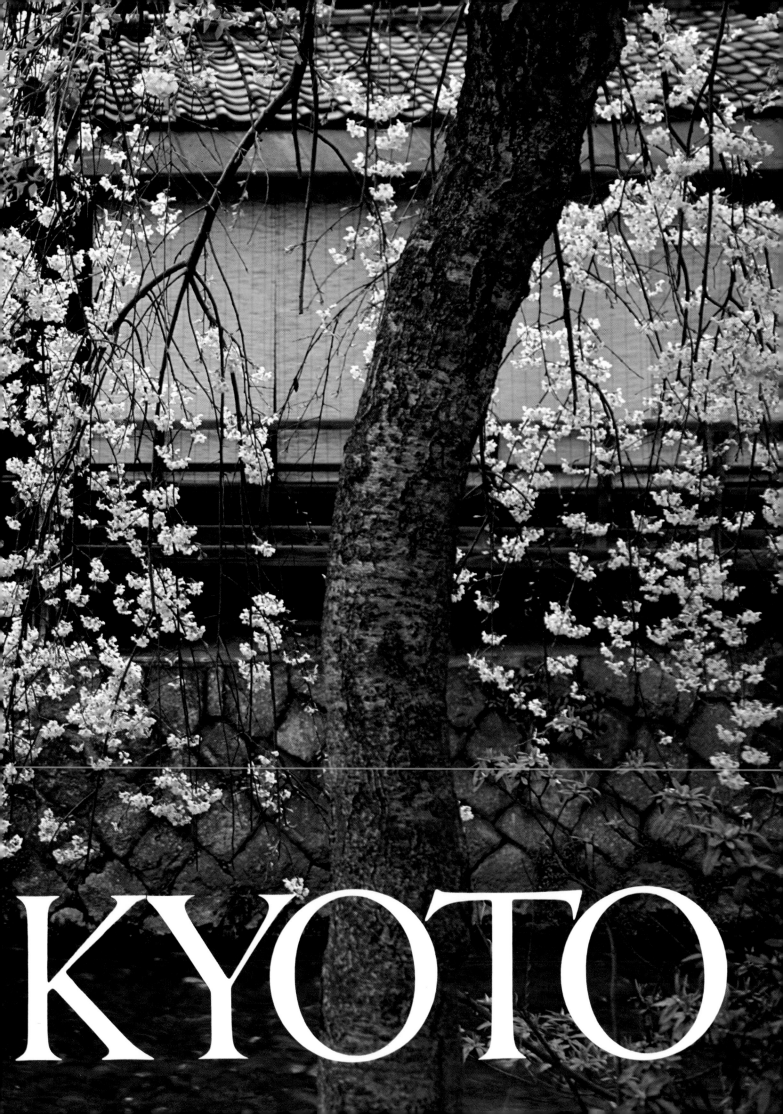

KYOTO

PHOTO CREDITS: Akira Okumura, 39, 53, 54, 55, 56, 80, 81, 82, 83, 87; Asahi Shinbun Photo Service, title page; Bin Takahashi, 26; Bon Color Photo Agency, copyright page, 2, 11, 14, 19, 31, 32, 61; Camera Tokyo Service, 22, 36, 37, 40, 41, 42, 48, 49, 63, 68; Fine Photo Agency, 3, 6, 10, 17, 28, 35, 45, 60, 67, 71, 72, 73, 74, 75; Hiromi Nishiura, 85; Hiroshi Mizobuchi, half title page, 62; Katsuhiko Mizuno, 7, 43, 44, 46, 47, 65, 66, 69, 70, 76, 77, 78; Kiichi Asano, back jacket, 27, 64; Kotaro Kawabe, 84; Masahisa Fukase, 38, 57, 58, 59; Takeji Iwamiya, front jacket, 24, 33; Takeshi Nishikawa, 1, 21, 23, 30, 34; Tokyo National Museum, 12, 15, 16, 18, 20, 25, 29; Toru Minowa, 86; Rikio Yoshimura, 79; Yutaka Takanashi 50, 51, 52.

The Publishers would like to thank the following temples, shrines, and museums for allowing reproduction of objects in their collections: The Museum of Fine Arts, Boston, 13; Chion-in, 15, 16; Enryaku-ji, 5; Kitano Shrine, 12; Tō-ji, 8, 9; Tokyo National Museum, 18, 20, 25, 29.

Distributed in the United States by Kodansha International/USA Ltd., through Harper & Row, Publishers, Inc., 10 East 53rd Street, New York, New York 10022.

Published by Kodansha International Ltd., 2-2 Otowa 1-chome, Bunkyo-ku, Tokyo 112 and Kodansha International/USA Ltd., 10 East 53rd Street, New York, New York 10022. Photographs Copyright © 1979 by Kodansha International Ltd. Text Copyright © 1979 by Kodansha International Ltd. All rights reserved. Printed in Japan.

LCC 79-51164
ISBN 0-87011-384-4
ISBN 4-7700-0728-0 (in Japan)

First edition, 1979
Tenth printing, 1989

CONTENTS

FOREWORD

KYOTO THEN AND NOW

When I was first living in Kyoto some twenty-five years ago nothing used to irritate me more than to be informed by people who remembered the city's appearance ten or fifteen years earlier, "You should have seen Kyoto in the old days." They recalled Kyoto when gasoline was rationed and there were almost no cars in the streets; they described the great temple Kinkaku-ji before an insane monk burnt it; they praised the huge weeping cherry tree in Maruyama Park which (like various other famous trees of the region) seems to have withered away even as I approached Japan; they regretted that the Kyoto dialect had been corrupted by an admixture of standard Japanese. Such comments were exasperating because I had become convinced that Kyoto was the city I liked best in the whole world, and it pained me to think that I had missed seeing it when it was even more agreeable. I made the solemn resolution never to tell future visitors to Kyoto that they should have seen the city in the old days, though at times the temptation has been strong to break it.

The first house I lived in while studying in Kyoto lay in the shade of Kinugasa-yama, a lovely curved mountain with a line of pines at the crest like a mane in the wind. The building next door was a school for small but noisy children, so I would often study at the nearest temple, the Tōji-in. At the time the temple was usually deserted. No one claimed an admission fee at the door, and no one, for that matter, offered to guide visitors. I never even saw a priest, but two or three students were living there while they prepared to take the university entrance examinations. There was no one to keep me from stepping down into the garden and walking round the pond to the tomb of the fourteenth-century shogun Ashikaga Takauji. Next to the main temple building was a dark little hall with wooden statues of the Ashikaga shoguns sitting in two rows facing each other. I remember especially the glass eyes glowing in the dark. Even in summer this was a chilly place.

I revisited the Tōji-in not long ago. The buildings are much better cared for now than when I first knew them. No longer do tall weeds grow from the roof of the main gate, and fragments of the *fusuma-e*, paintings on the sliding wall partitions, are now preserved behind glass, though in the old days they were exposed for every casual visitor to paw at. There is more of the garden to see. Indeed, I had never even been aware of the existence of a second, larger pond. They charge an admission fee now, and picture postcards are available, but the statues of the Ashikaga shoguns maintain their old, forbidding dignity.

I used also to visit the temple just beyond the Tōji-in, the famous Ryōan-ji. I had

heard about its famous sand and stone garden long before my first visit to Kyoto, but it proved more impressive in reality than I had imagined it. Even at the time there were purists to insist that the trees on the other side of the garden wall had grown too tall, but nothing—not even the inane comments of guides and tourists—could alter my conviction that this was one of the unforgettable sights of the world. I used sometimes to go to the Ryōan-ji on moonlit nights. There was no one to prevent a visitor from entering the temple even after dark. One night as I sat gazing at the shadows cast on the sand by the rocks in the moonlight, I heard a slight noise. An old lady, perhaps the priest's wife, had silently come up beside me and placed a teacup on the wooden boards. We started to talk. She told me that long ago, when she was hardly more than a girl, she had traveled to California as a "picture bride" only to be rejected by a man who sent her back to Japan. I asked if she remembered anything of California. "Yes," she said, "I climbed a tall mountain. It was very tall, even taller than Hiei-zan." Hiei-zan is less than three thousand feet high, but to someone from Kyoto it is the standard by which all other mountains are evaluated.

One other temple had special importance for me during the years I lived in Kyoto, the Chishaku-in, diagonally across the city from Kinugasa-yama and near the Kyoto Museum. After I had moved to my second house, on the steep road leading to Yamashina, I decided to take calligraphy lessons, and went to the nearest temple, the Chishaku-in, sure that some learned monk would be willing to instruct me. As it happened, I was right, though this was no more than a lucky accident. Visiting the Chishaku-in regularly for lessons also enabled me to become thoroughly familiar with the celebrated *fusuma-e* painted by Hasegawa Tōhaku, perhaps the most beautiful in Japan, and with the lovely garden laid out in the sixteenth century. I became friendly with the priests, and once helped to ring in the New Year by striking the temple bell at midnight. (As a "penalty" I was obliged to drink one cup of saké for each stroke of the bell I had sounded.) I remember too a little party in the moon-viewing pavilion adjoining the garden. Last year I visited the Chishaku-in after ten or more years. The *fusuma-e* are now housed in a fireproof concrete structure with music and a disembodied voice piped in, and the garden now must be approached by a disillusioning back way. The poetry is gone, but only an old-timer like myself would suspect it.

Yet despite the changes of the past twenty-five years, the magic of Kyoto has not disappeared. The city is famed especially for its springs and autumns, but I think I like it best in the winter, when everyone is busy with New Year preparations and there are few tourists. The temples, even the Sanjūsangen-dō, that Mecca of every schoolchild, are deserted, and one can admire the thousand and one Buddhas all by oneself. There is a festive air about the city, even though cold winds blow, and never do the many shops look so attractive. I enjoy especially shopping for *wagashi* (Japanese cakes), those tiny miracles of aesthetic genius, though I am rarely tempted to eat any.

Last year I spent a few days in Kyoto late in December, towards the end of the *kaomise* Kabuki performances at the Minami-za. This curious, not very beautiful theater enshrines my happiest memories of Kabuki, and to see a performance there is a totally different experience from one at the aseptic National Theater in Tokyo. The atmosphere is special, and attending the theater is the occasion for the ladies of Kyoto to display their own finery and to examine what their neighbors are wearing.

I like the sounds of Kyoto speech as one hears it from spectators at the theater. It is a hackneyed observation to insist that the Kyoto dialect is charming when spoken by a woman but slovenly in a man's mouth, but—perhaps because Kyoto was the first Japanese city where I lived—the sound of Kyoto speech, whoever is talking, makes me nostalgic, and I find myself imperceptibly falling into a similar manner when conversing with people of the city. I enjoy going into a dusty little shop in a low wooden building and chatting with the owner as I examine bamboo brooms, combs in two dozen distinct shapes, neckties made of kimono material, or any of the other curious bits of handicraft that seem to belong peculiarly to Kyoto. In many of the shops the owners sit on raised, *tatami*-covered platforms like those one sees in the old prints and seem glad of the opportunity to chat, even if there is little chance of a sale.

Then there are the restaurants and drinking places. I am convinced that Kyoto cuisine ranks among the finest in the world. When I lived in Kyoto I was lucky in that the landlady, who prepared all my meals, was a great cook. I felt sorry for people whose only experience of Japanese cuisine was in the restaurants. But the Kyoto restaurants—not only the famous, expensive ones—often have a special charm. I have particularly affectionate memories of the restaurant in the grounds of the Nanzen-ji, where one sits outdoors on little platforms under the trees overlooking a pond. The restaurant is more crowded than it used to be, and the prices, though reasonable, are higher, but there cannot be many restaurants in the world with more pleasant surroundings.

I suppose that in my heart I bitterly resent every change that has taken place in Kyoto. I hate the Kyoto Tower. I miss the old trams. I do not wish to motor along the scenic highways that have been slashed into the hills. But whatever reservations I have about the changes that have affected the city are swept away when I am actually there. Recent visitors to Kyoto who find it enchanting are not mistaken. I believe that it was even more enchanting twenty-five years ago, but perhaps it is I who have aged, rather than Kyoto. Then as now there were people to say that Kyoto was better in the old days. They were both right and wrong. Every improvement in the living standards of the inhabitants has inevitably involved destruction of the past, and people who reminisce about the old days, when they themselves were young, tend to forget the disagreeable aspects—the vile-smelling nightsoil trucks, the constant dust from the unpaved streets, the misery revealed by the ramshackle huts here and there in the city. Perhaps the present, despite the wounds men have dealt the past, is a better place to live in. At any rate, I have fulfilled my promise. I do not tell visitors that they should have seen Kyoto in the old days, though perhaps, in my heart, I really think they have come a little late.

<div align="right">

DONALD KEENE
Tokyo, May 1979

</div>

PLATES 1–14. THE HEIAN PERIOD (794–1185)
AFTER ITS FOUNDATION, KYOTO ENJOYED A LONG PERIOD OF PEACE
AND PROSPERITY. THE CULTURE OF THE FIRST HALF OF THE PERIOD
WAS PREDOMINANTLY CHINESE, BUT IN THE LATTER HALF A PURELY
JAPANESE CULTURE EVOLVED AND REACHED GREAT HEIGHTS IN
ARISTOCRATIC SOCIETY.

1. One of the latticed, hinged doors of the Seiryō-den, or "Pure
Cool Hall," so called from the stream that runs under the steps.
Built of Japanese cypress wood, this private residence of the
emperors is one of the buildings of the Imperial Palace, with the
sixteen-petaled imperial crest prominent on the wooden beams.

HEIAN SHRINE
CONSTRUCTED IN EIGHTH-CENTURY CHINESE STYLE, THE PRESENT-
DAY HEIAN SHRINE WAS ERECTED IN 1895 TO MARK THE ELEVEN-
HUNDREDTH ANNIVERSARY OF THE FOUNDING OF KYOTO. THE
SHRINE IS DEDICATED TO EMPEROR KAMMU, THE CITY'S TUTELARY
DEITY, AND THE MAIN BUILDING IS A COPY ON A REDUCED SCALE
OF THE FORMER GREAT HALL OF STATE USED FOR ENTHRONEMENT
CEREMONIES IN HEIAN TIMES.

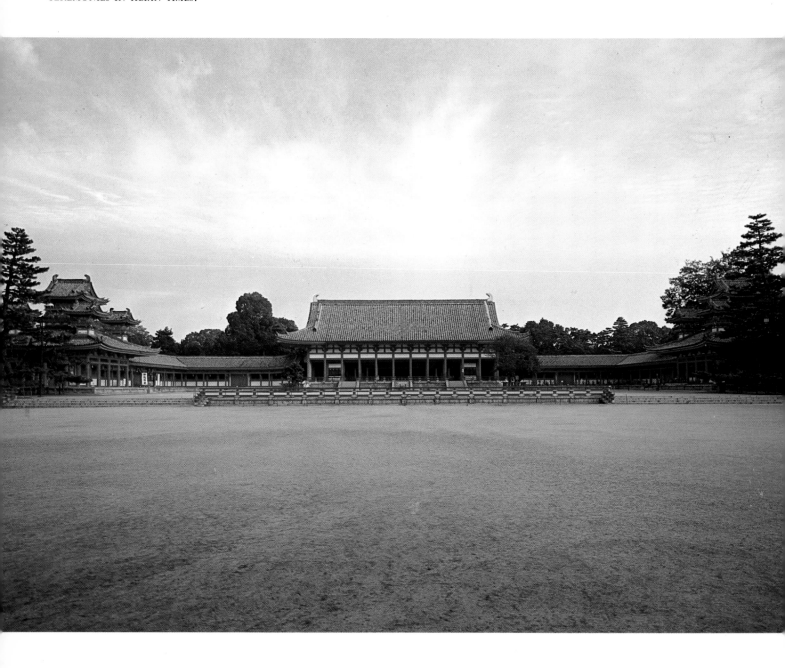

2, 3. The Heian Shrine consists of five buildings, of which the
Great Hall of State and its two flanking towers are shown above.
All the buildings have blue roof tiles and are painted bright red.
Right: The two-storied Ōten-mon Gate, as denoted by the
wooden sign beneath the roof, is a replica of the principal gate
of the former Great Hall of State.

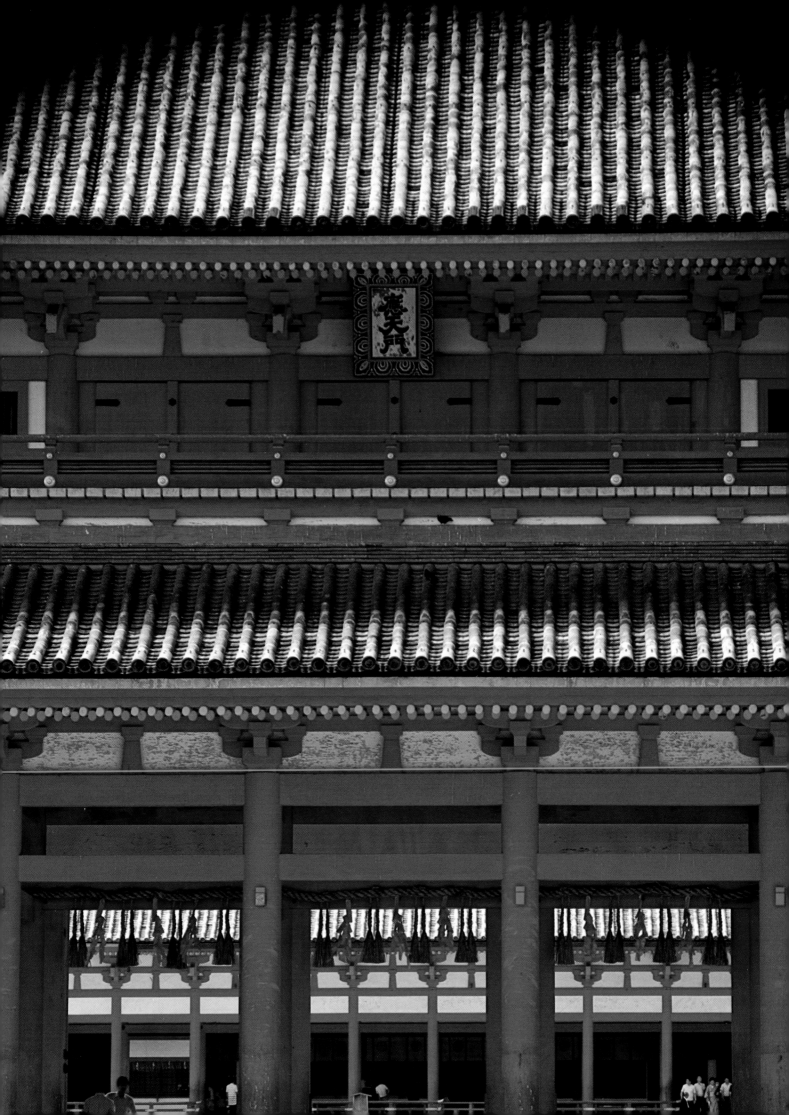

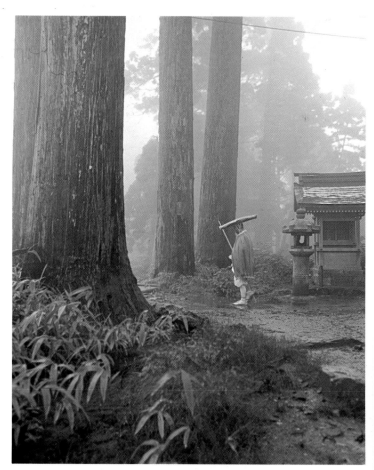

INTRODUCED FROM CHINA BY SAICHŌ (767–822), WHO FOUNDED THE TEMPLE OF ENRYAKU-JI ON MT. HIEI, TENDAI ATTEMPTED TO INCORPORATE ALL BUDDHIST LEARNING INTO ONE GRAND HIERARCHICAL SCHEME. IT PREACHED THAT THE TEACHINGS OF BUDDHA WERE ACCESSIBLE TO ALL, NOT MERELY TO AN ELITE, WHICH RESULTED IN ITS GREAT POPULARITY IN THE HEIAN PERIOD.

5. The *Lotus Sutra*, of which one section is shown here in a ▷ scroll with gold and silver calligraphy, is the fundamental text of Tendai, purporting to be the definitive teachings of Buddha and to establish the one way to attain Buddhahood.

4. A priest from Mt. Hiei's Enryaku-ji, located among stands of Japanese cypress trees, sets off to undergo a thousand days of austerities, believed to grant special powers to priests.

6. The Konpon Chū-dō (Fundamental Central Hall), the main hall of Enryaku-ji, was first built by Saichō in 794 to house a statue of Yakushi Nyorai, the Buddha of Healing, that he is said to have carved himself. The present structure dates from 1642. The curved gable over the entrance and the copper roof on the outer corridors reflect the bold style of the seventeenth century.

切己心不慊遠無求出意令利弗是長者作
是思惟我身手有力當以衣裓若以几案從
舍出之後更思惟是舍唯有一門而復狹小
諸子幼稚未有所識慈著戲處或墮落為
火所燒我當為說怖畏之事此舍已燒宜時
疾出無令為火之所燒害宜告作是念已如所思
惟具告諸子汝等速出父雖憐愍善言誘喻
而諸子等樂著嬉戲不肯信受不驚不畏了
無出心亦復不知何者是火何者為舍云何
為失但東西走戲視父而已介時長者即作
是念此舍已為大火所燒我及諸子若不時
出必為所焚我今當設方便令諸子等得免
斯害父知諸子先心各有所好種種珍玩奇
異之物情必樂著而告之言汝等所可玩好
希有難得汝若不取後必憂悔如此種種羊
車鹿車牛車今在門外可以遊戲汝等於此
火宅宜速出來隨汝所欲皆當與汝介時諸
子聞父所說珍玩之物適其願故心各勇銳
互相推排競共馳走爭出火宅是時長者見
諸子等安隱得出皆於四衢道中露地而坐
無復障礙其心泰然歡喜踊躍時諸子等
白父言父先所許玩好之具羊車鹿車牛車
願時賜與舍利弗爾時長者各賜諸子等一

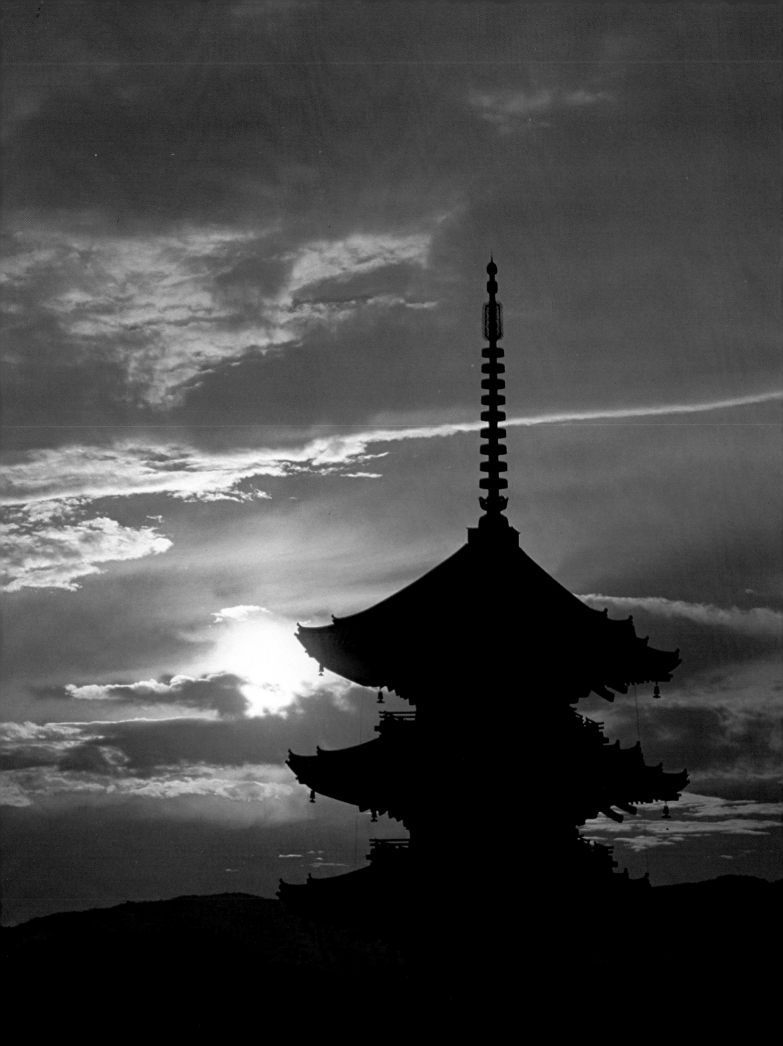

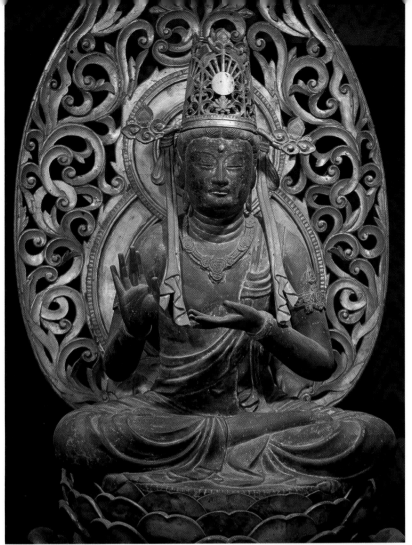

THE SHINGON SECT
ONE OF THE TWIN MAINSTREAMS OF JAPANESE BUDDHISM,
TOGETHER WITH TENDAI, THIS ESOTERIC BUDDHIST SECT
WAS INTRODUCED FROM CHINA BY KŌBŌ DAISHI, ALSO
KNOWN AS KŪKAI (774–835), WHO FOUNDED THE TEMPLE
OF TŌ-JI IN 823. SHINGON, WHICH PLACED EMPHASIS ON
RITUAL, SYMBOLISM, AND ICONOGRAPHY, SOON GAINED A
LARGE FOLLOWING AMONG THE COMMON FOLK.

8. Tō-ji has a large number of Buddhist statues dating from the Heian period (794–1185). This is Vajrakarman, one of the Five Great Bodhisattvas, who have temporarily refused Buddhahood in order to save mankind.

9. A mandala—a pictographic aid to meditation—of the Buddhist universe, representing the cosmic Buddha's manifestation of his immanence in everything. This is a detail of the Taizō-kai (Womb) Mandala, one of the two principal mandalas of Shingon.

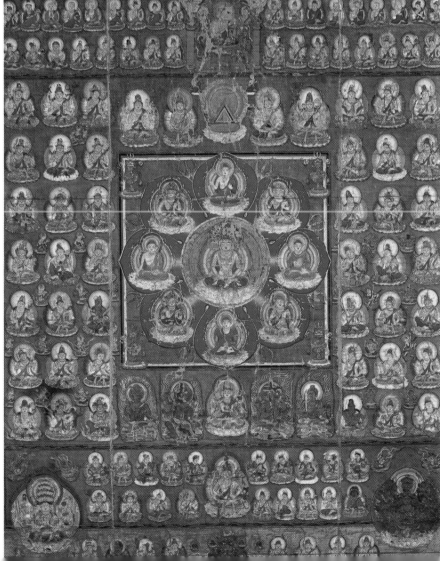

◁7. The pagoda of Tō-ji, one of the two main temples of the Shingon sect, is the tallest in Japan at 180 feet. Dating from 1644, its five stories symbolize the five elements—fire, water, earth, wind, and air; the rings at the top represent the nine spheres of Heaven.

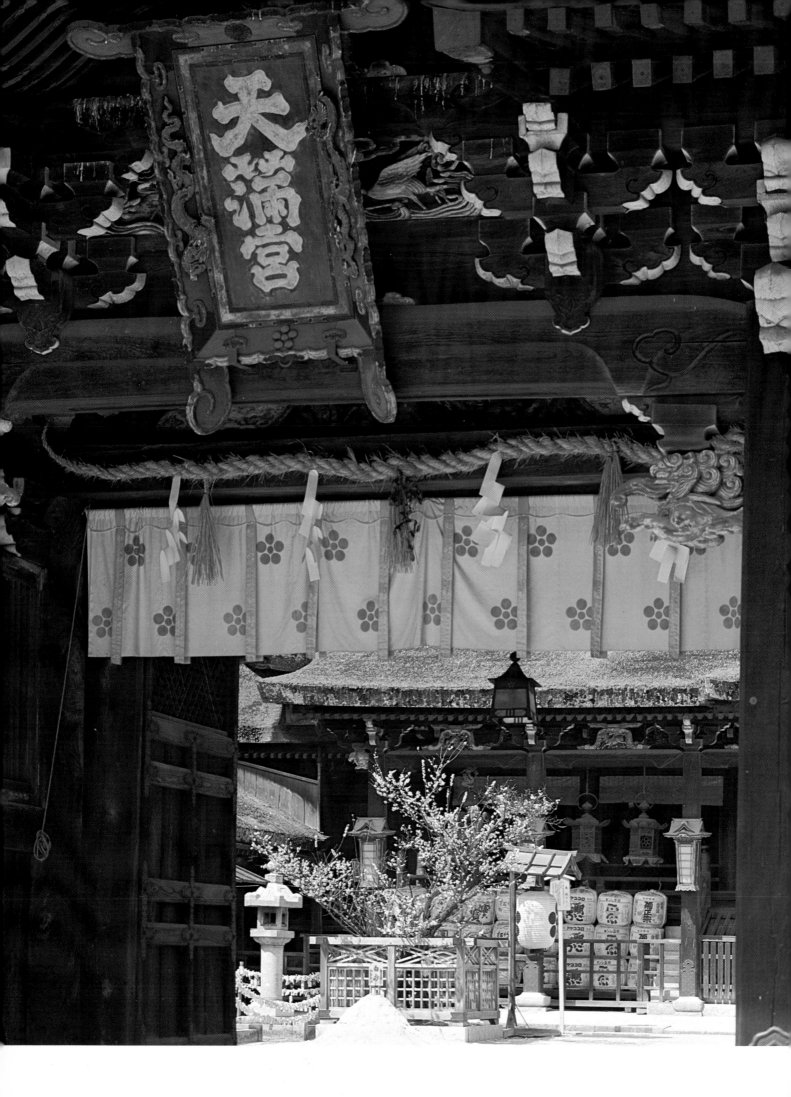

KITANO SHRINE, OR TENMAN-GŪ, WAS FIRST
ERECTED IN 959 TO APPEASE THE SPIRIT OF THE
STATESMAN AND POET SUGAWARA NO MICHI-
ZANE (845–903), WHOSE DEATH WAS FOL-
LOWED BY A SERIES OF EARTHQUAKES AND
VIOLENT THUNDERSTORMS. THE PRESENT
BUILDINGS WERE CONSTRUCTED FROM 1607,
AND INCLUDE THREE GATES, A MAIN HALL,
AND AN ORATORY.

10–11. *Left:* The shrine buildings are
noted for their carved eaves and roofs of
cypress bark. The thick rope, present at all
shrines, separates sacred territory from
secular territory, and the short, white cur-
tain is emblazoned with the crest of Michi-
zane. *Right:* Visible through the white
plum blossoms, a favorite theme of Michi-
zane's poems, is a lantern also decorated with
his crest.

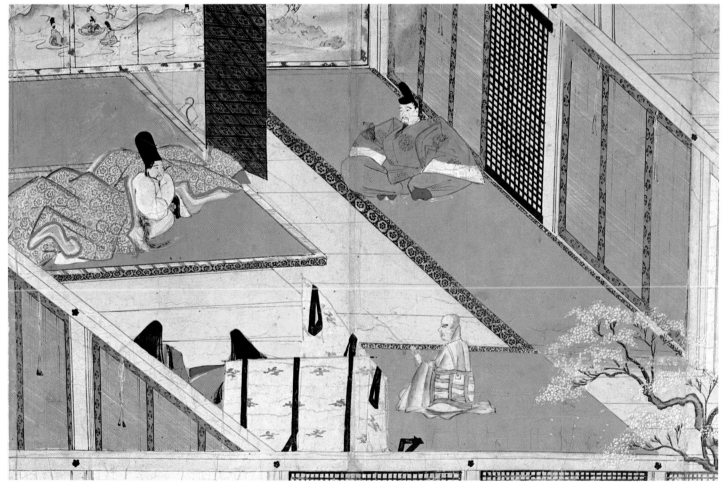

12. This scene from the *Kitano Tenjin Scroll* depicts Sugawara no
Michizane shortly before his death in exile in Kyushu. The arrange-
ment of the room is typical of the Heian period, when the nobles
slept on elevated tatami mats, which could be separated from the
rest of the room by folding screens.

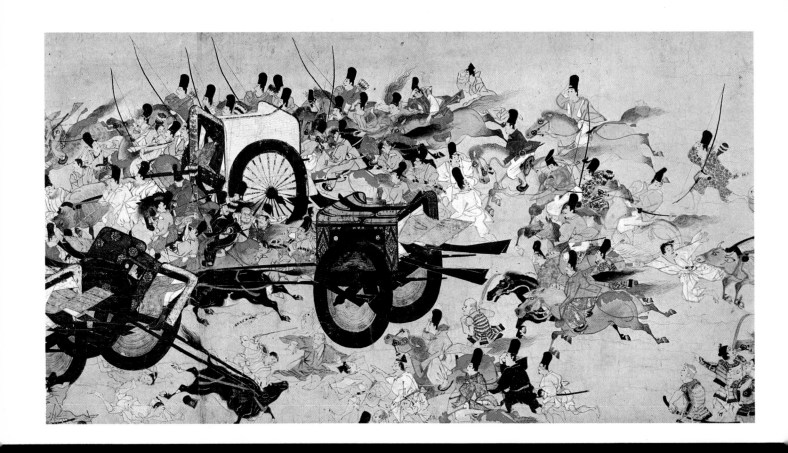

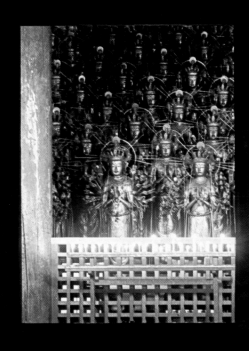

THE RISE AND FALL OF THE TAIRA CLAN
AT THE END OF THE HEIAN PERIOD, DISCORD BETWEEN THE REIGNING
AND RETIRED EMPERORS AND WITHIN THE POWERFUL FUJIWARA
FAMILY BROUGHT THE LONG ERA OF PEACE TO AN END AND TWO
FACTIONS AROSE—THE TAIRA AND THE MINAMOTO CLANS. THE
TAIRA WERE THE VICTORS OF THE HEIJI WAR (1159) AND FOR TWO
DECADES HELD THE REIGNS OF POWER, UNTIL THEIR DEFEAT BY THE
MINAMOTO CLAN USHERED IN THE KAMAKURA PERIOD.

◁13. This painting from the *Heiji Scroll* depicts the turmoil at the end of the Heian period, when the streets of the capital were transformed into a battlefield. Here troops of the Minamoto clan stage a night attack on the palace of ex-Emperor Goshirakawa in the Heiji War of 1159.

14. Sanjūsangen-do, a temple built by Taira no Kiyomori in 1164 at the request of ex-Emperor Goshirakawa, is famous for the one thousand and one images of the Thousand-armed Kannon, the bodhisattva of mercy and compassion. The temple's name refers to its length of 33 *ken* (129 yards) and the thirty-three shapes Kannon can assume, according to the *Lotus Sutra*. People believe a resemblance to a dead relative can always be found in one of the statues.

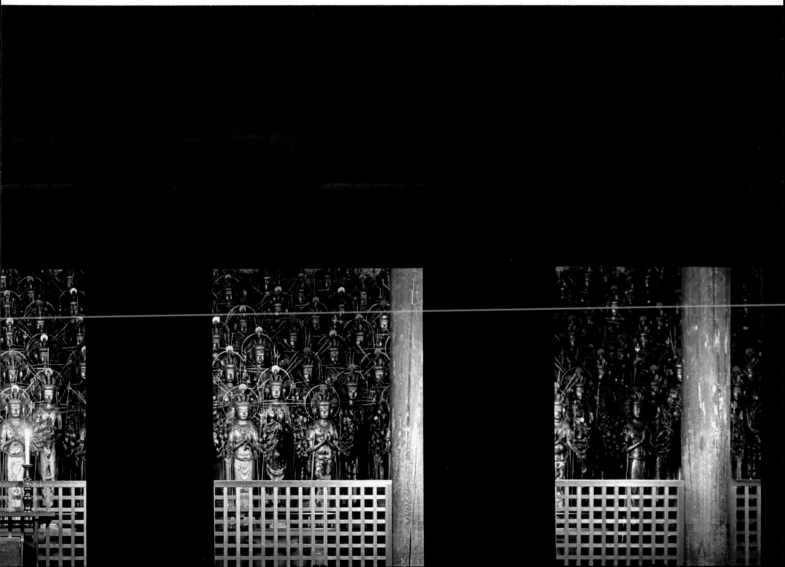

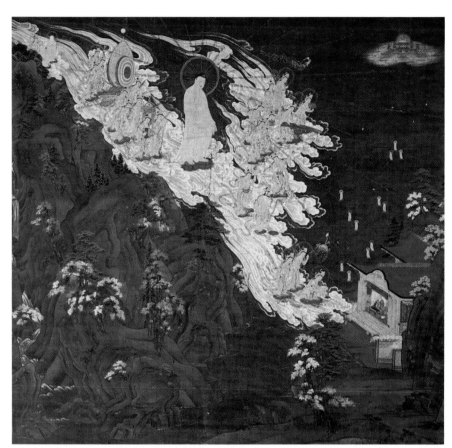

PLATES 15–17. THE KAMAKURA PERIOD (1185–1333)
THE NEW AND INDEPENDENT GOVERNMENT ESTABLISHED BY THE WARRIOR CLASS AT KAMAKURA STRESSED VIGOROUS MASCULINE ATTRIBUTES AS OPPOSED TO ARISTOCRATIC QUALITIES. SOCIAL UPHEAVALS IN THE EARLY PART OF THE PERIOD LED PEOPLE TO DEMAND SIMPLER FAITHS THAN THE BUDDHISM THAT HAD GONE BEFORE. FOREMOST AMONG THE NEW FAITHS WAS THE JŌDO SECT, STARTED BY HŌNEN (1133–1212), WITH ITS COMPASSIONATE BELIEF THAT BY THE EVOCATION OF AMIDA'S NAME, ONE COULD BE REBORN IN THE WESTERN PARADISE.

15. This painting, called *Haya Raigō*, depicts the descent of the Buddha Amida to welcome the souls of the newly dead and the faithful. Amida is shown surrounded by twenty-five bodhisattva attendants.

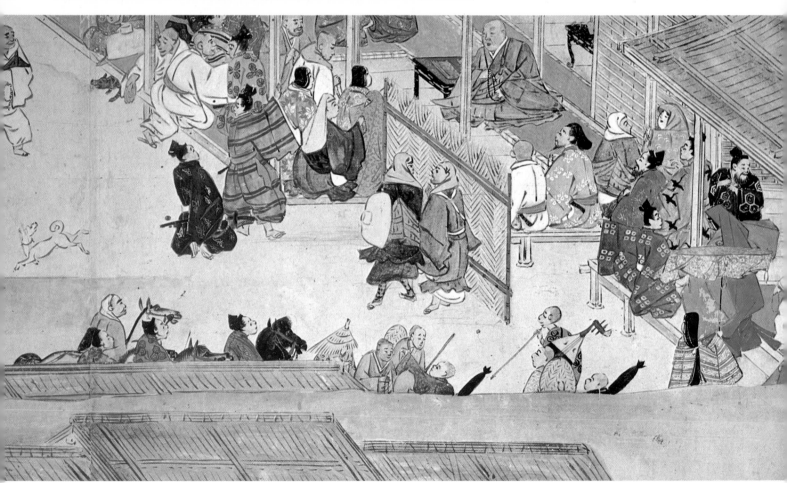

16. This scene from the *Hōnen Scroll* shows the priest Hōnen seated on a platform and preaching Amida Buddhism to simple folk on his way to exile on the island of Shikoku. He was pardoned in 1211, one year before his death in Kyoto.

17. The main gate of Chion-in Temple, the principal temple of ▷ Hōnen's Jōdo sect of Buddhism, is the largest gate in Japan and was built in 1619 at the request of the second Tokugawa shogun, Hidetada. This view of the gate is taken from the temple.

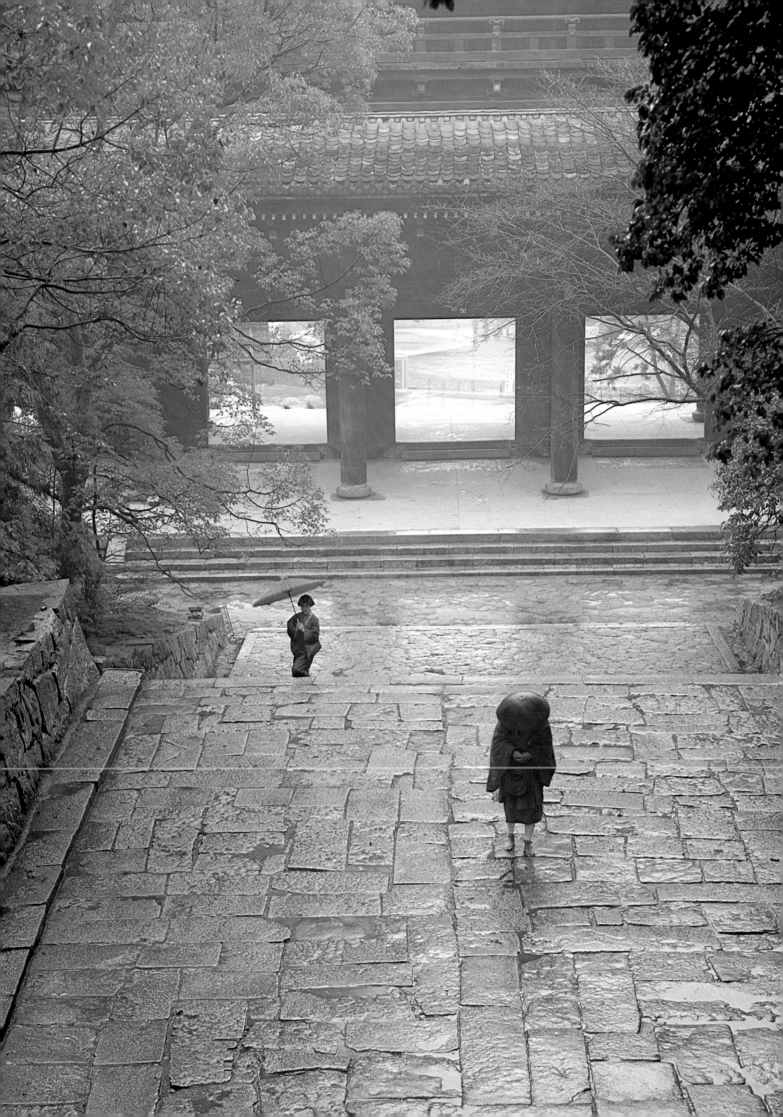

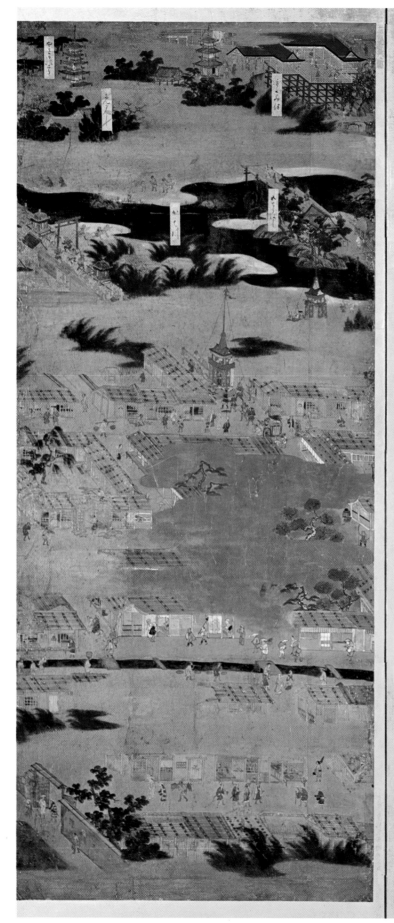
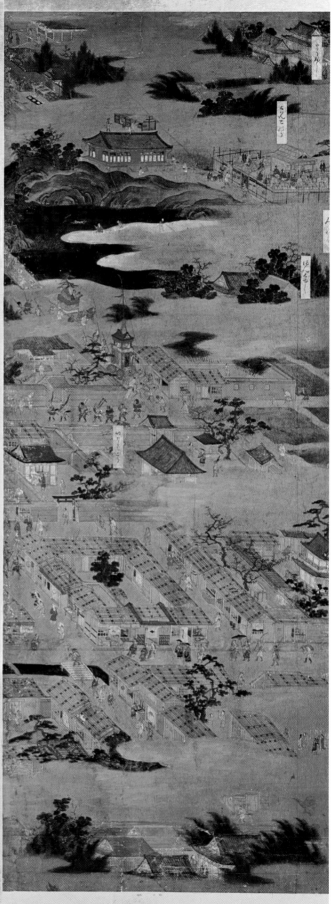

PLATES 18–24. THE MUROMACHI PERIOD (1338–1573)
WITH TWO CLAIMANTS FOR THE THRONE, KYOTO WAS ONCE MORE
BESET BY CIVIL WARS UNTIL THE TWO LINES WERE RECONCILED
IN 1392. DESPITE THE TURBULENCE THAT MARKED IT, THE MURO–
MACHI PERIOD WAS A GOLDEN AGE ARTISTICALLY.

18. In the sixteenth century a number of views of Kyoto were painted on folding screens for feudal lords living in the provinces. The upper portion of this one shows the Kamo River, Kiyomizu-dera Temple, and Yasaka Pagoda. Below the river are the floats of the Gion Festival being drawn through the merchant quarters.

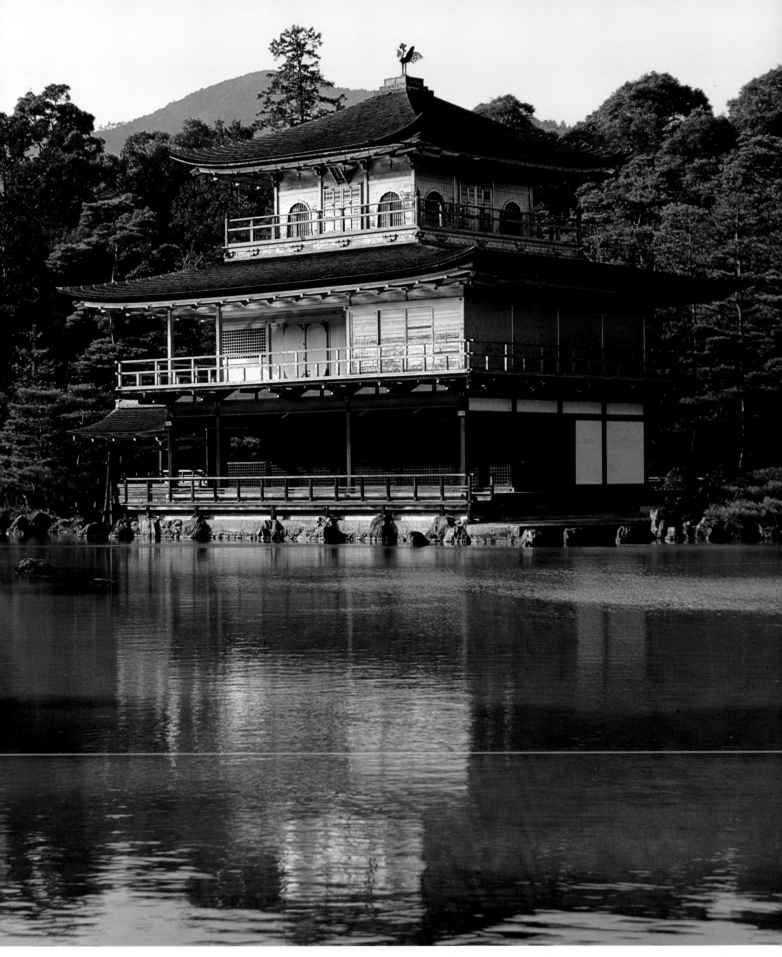

19. Kinkaku-ji, or the Golden Pavilion, was built in 1397 by Shogun Ashikaga no Yoshimitsu. In keeping with the founder's wish, the pavilion was turned into a Zen temple on his death. The first floor is reminiscent of Heian-period architecture, the second is like a temple hall, while the third resembles a Zen cell.

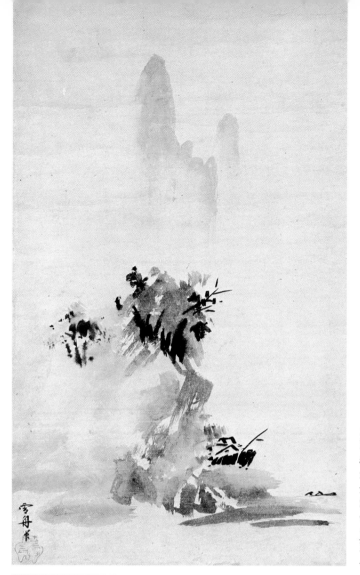

ZEN BUDDHISM

INTRODUCED FROM CHINA BY THE MONK EISAI (1141–1215) AND HIS DISCIPLE DŌGEN (1200–53), ZEN BUDDHISM BECAME POPULAR IN THE MUROMACHI PERIOD. ZEN STRESSED MEDITATION, STRICT DISCIPLINE, AND SALVATION THROUGH SELF-UNDERSTANDING AND SELF-RELIANCE. WITH ITS EMPHASIS ON A SIMPLE LIFE AND THE REJECTION OF SCHOLAS-TICISM, IT WAS ESPECIALLY FAVORED BY THE WARRIOR CLASS.

20. This black ink landscape was painted by Sesshū (1420–1506) in 1495. Severe in color and economical in line, this type of painting conveys the essential spirit of Zen. It originated in China as a hobby for Zen priests, and eventually became the basis of the "Chinese school" of painters, of which Sesshū is the most famous.

21, 22. *Below:* The dry landscape garden of Daisen-in, a subtemple of Daitoku-ji, was created by Sōami (d. 1529), poet, painter, tea master, and garden designer, in 1513. Consisting mainly of rocks and sand, representing mountains and rivers, the garden creates an illusion of reality, thereby pointing to the ultimate emptiness of all things. Shown here is a stone boat on a river of sand. *Right:* A stone path-way with bamboo railings leads into Kōtō-in, a subtemple of Daitoku-ji, built by Hosokawa Sansai, a feudal lord and tea devotee, in 1601. It houses a famous tea room that was built by one of Rikyū's disciples —simple in style and austere in decoration.

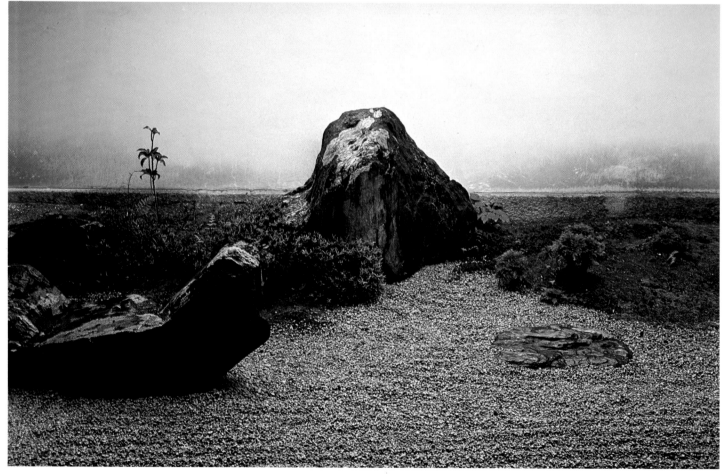

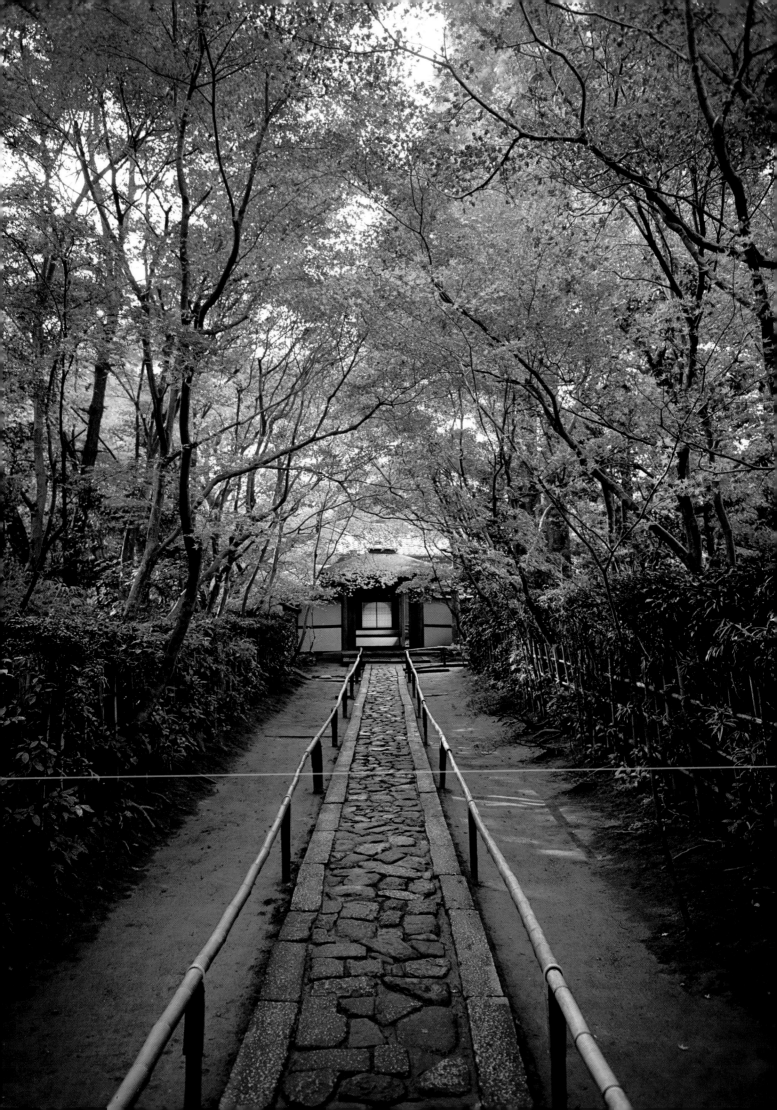

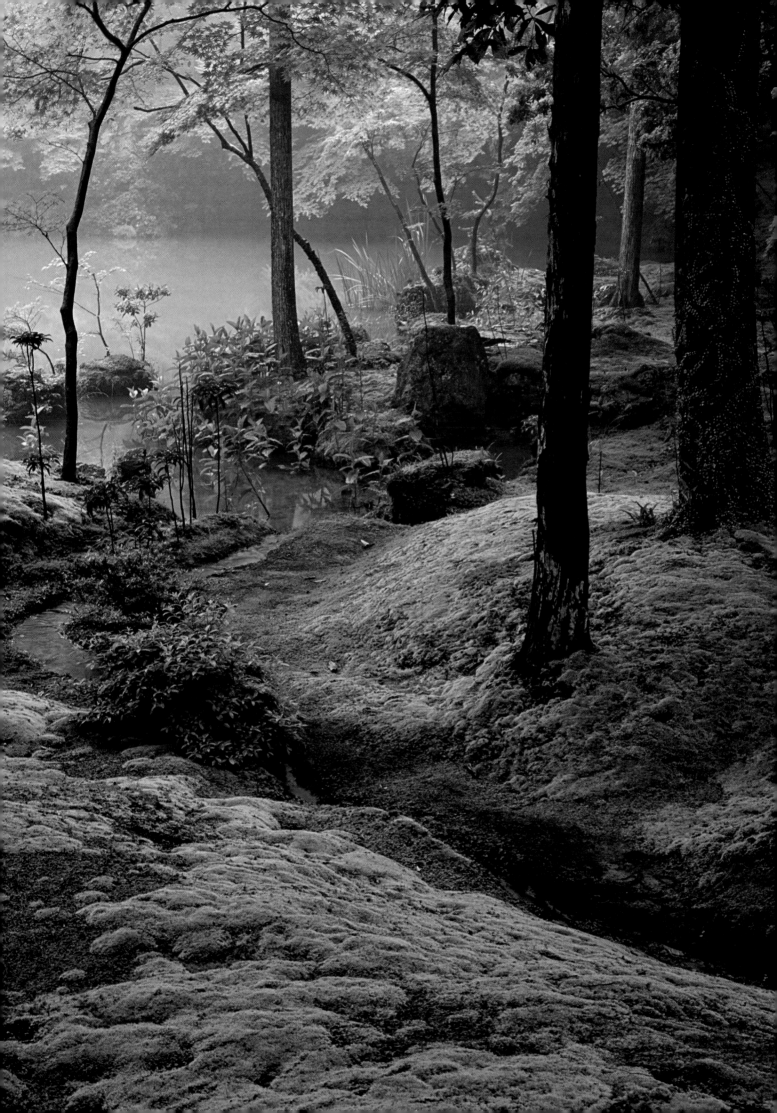

ZEN GARDENS

ONE OF THE ARTS THAT FLOURISHED UNDER THE INFLUENCE OF
ZEN WAS GARDEN ARCHITECTURE. ALTHOUGH THE JAPANESE GARDEN
WAS ALWAYS A REPLICA OF NATURE IN MINIATURE, IN THE FOUR-
TEENTH CENTURY THE SIZE WAS FURTHER REDUCED AND THE TREES
AND SHRUBS REPLACED BY ROCKS AND SAND.

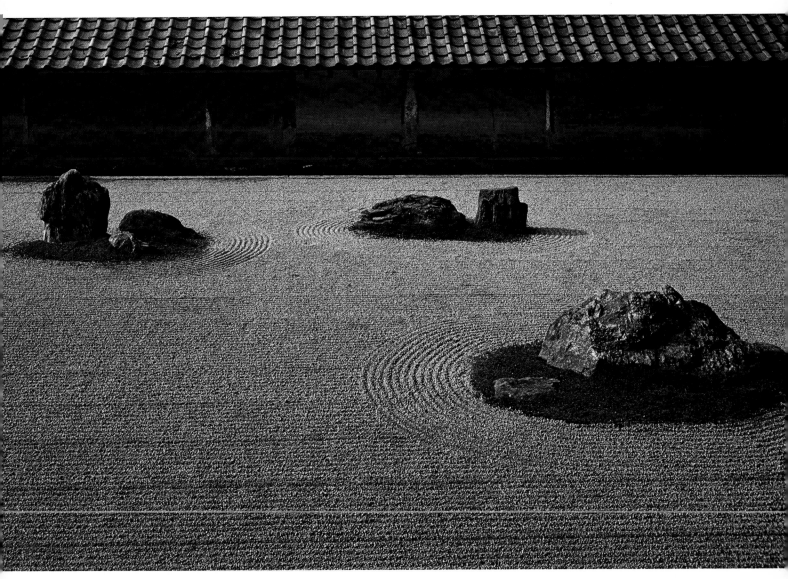

24. The stone garden of Ryōan-ji, laid out in the fifteenth century,
is famous for the fifteen rocks, arranged in five groups, on raked
sand. The harmony in the color, shape, and size of the rocks makes
this one of the most subtle and powerful gardens in Japan. The
rocks can be interpreted as islands in a river or as high peaks
soaring over clouds.

◁23. The moss garden of Saihō-ji, also called Koke-dera, or Moss
Temple, was designed by the Zen priest Musō Kokushi (1275–
1351) in 1339. One of the finest gardens in Japan, its grounds are
covered with over forty species of moss, each with its own shade
of green, suggesting nature's variety and, at the same time, the
ultimate oneness of all things. Moss symbolizes the timeless aspect
of nature by its tendency to cover hewn stones and other man-
made objects, thus bringing to nought all of man's creations.

THE CIVIL WARS WERE FINALLY BROUGHT TO AN END BY ODA NOBUNAGA (D. 1582) AND
TOYOTOMI HIDEYOSHI (D. 1598), WHO SET ABOUT THE TASK OF UNIFYING THE COUNTRY.
THE TWO MEN, AND THE NEW MERCHANT CLASS THAT HAD PROSPERED DURING THE
WARS, HAD LAVISH TASTES, AND LARGE SCREEN PAINTINGS IN GOLD AND VIVID COLORS WERE
USED TO DECORATE CASTLES AND PALACES.

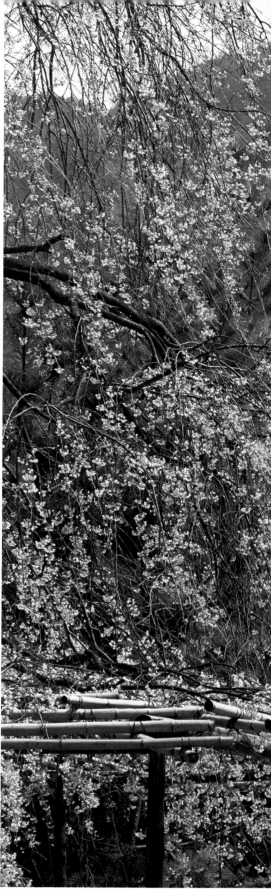

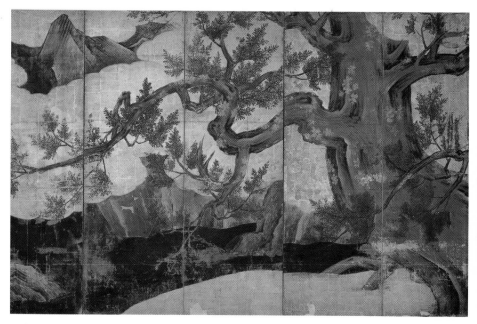

25. This vigorous cypress was painted for Toyotomi Hideyoshi's Kyoto castle by
Kanō Eitoku (1543–90). Eitoku, one of the most important figures in the history of
Japanese art, originated a magnificent style of wall decoration that used bold colors on a
gold ground.

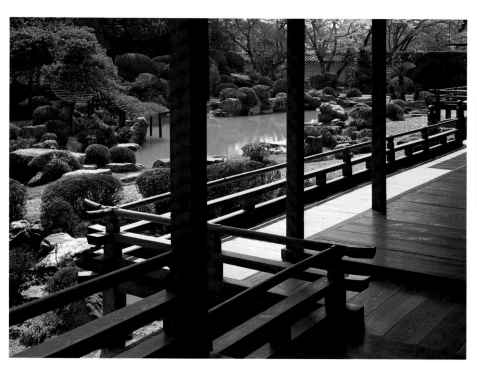

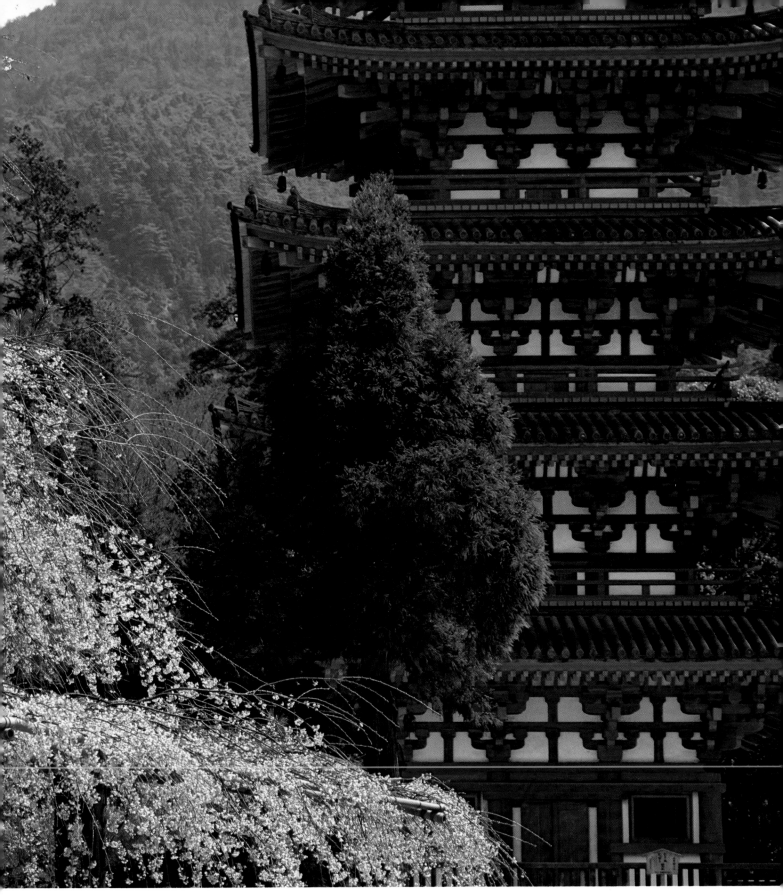

26, 27. *Left:* The garden of the Sambō-in, a subtemple of Daigo-ji, was laid out for Toyotomi Hideyoshi's cherry-blossom-viewing party of 1598. In Hideyoshi's time the garden was famous for its cherry trees and its pagoda. The design for the garden is said to be Hideyoshi's own, with islands, bridges, a lake, and waterfalls. *Above:* The five-storied pagoda of Daigo-ji Temple was built in 952, and took fifteen years to complete. In 1961, after repairs were undertaken, the pagoda was hit by a typhoon and began to lean slightly.

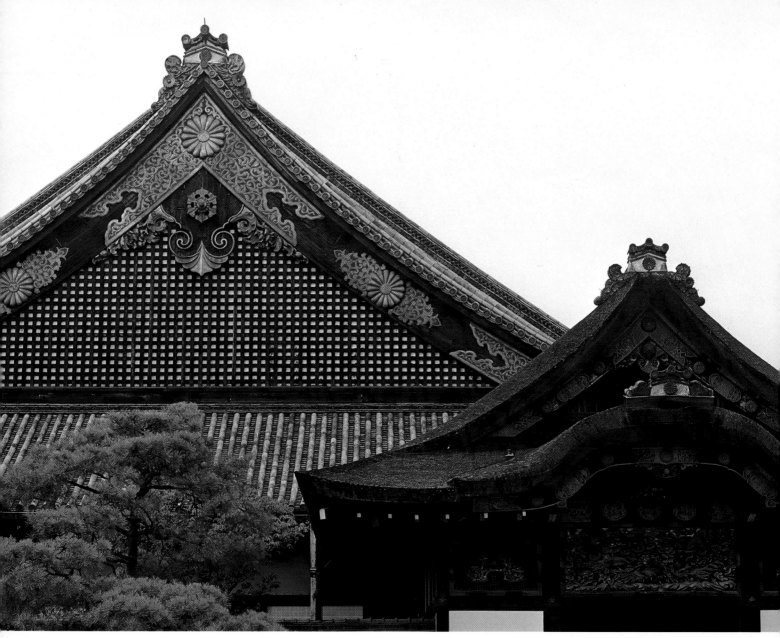

PLATES 28–31. THE EDO PERIOD (1603–1868)
IT WAS TOKUGAWA IEYASU WHO COMPLETED THE UNIFICATION OF
JAPAN AFTER HIDEYOSHI'S SUDDEN DEATH AND USHERED IN THE
EDO PERIOD WITH THE TOKUGAWA FAMILY AS SHOGUNS. THE PERIOD
IS MARKED BY ALMOST TOTAL ISOLATION IN NATIONAL POLICY UNTIL
1854, WHEN JAPAN OPENED HER DOORS TO THE WEST. IN 1867
THE EMPEROR WAS RESTORED TO HIS FORMER POWER AND IN
1869, THE COURT MOVED EAST TO TOKYO.

28. This shows the gables of the entrance hall and main audience
hall of Nijō Castle, built in 1603 by Tokugawa Ieyasu, founder of
the Tokugawa shogunate. The builders of the castle tried to blend
warrior taste with that of the aristocracy. The roof of the entrance
hall is covered with cypress bark, while that of the audience hall
is tiled. The sixteen-petaled imperial crest prominent on the main
audience hall was added in the Meiji period.

30. The Shōkin-tei is a rustic tea hut in the garden of the Katsura ▷
Imperial Villa that was built in the seventeenth century for a
retired prince. The villa contrasts sharply with contemporary
military structures such as Nijō Castle, and its superb garden
extends over some 6,000 square yards. The Shōkin-tei, one of the
tea huts in the Imperial Villa, served as a retreat for aesthetic
pastimes like the tea ceremony, painting, and poetry composition.

29. This painting done at the beginning of the seventeenth century depicts a typical scene of the time when women performed Kabuki dances on the dry bed of the Kamo River (now Kawaramachi).

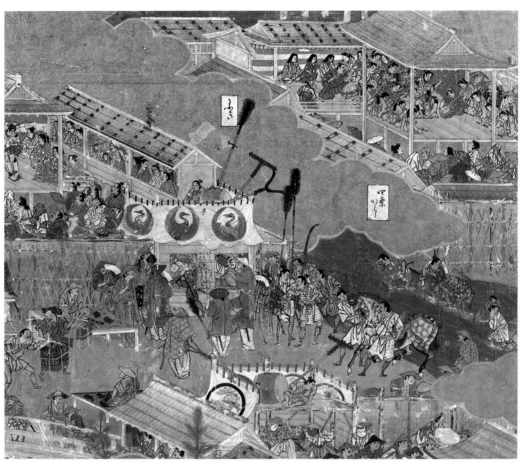

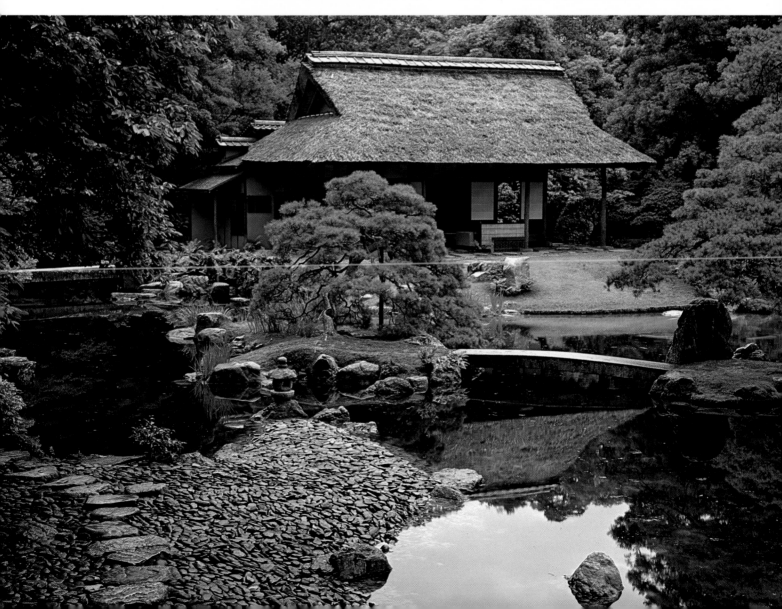

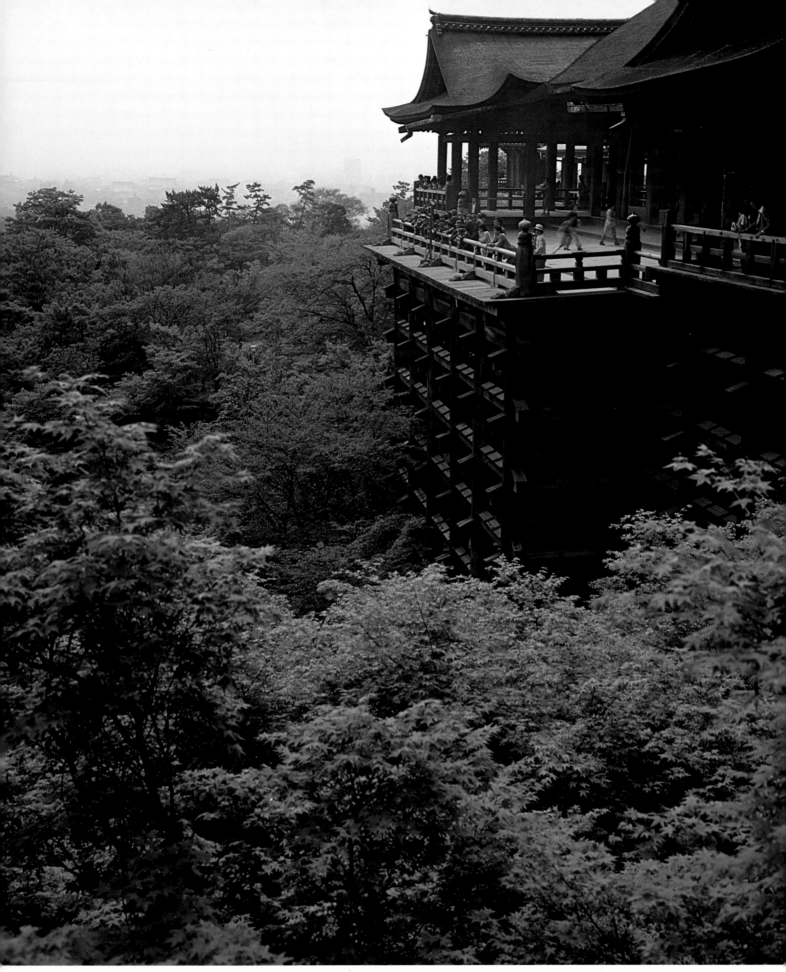

31. The main hall of Kiyomizu-dera Temple, famous throughout Japan, was once part of the imperial palace at Nagaoka, which was dismantled and transported here to be reconstructed as a temple hall. The present structure dates back to the first half of the seventeenth century. The temple has a large terrace built on a system of pillars without a single nail, and contains a statue of an eleven-faced, thousand-armed Kannon, to whom it is dedicated.

HISTORICAL KYOTO

The year 1869 brought sadness to the people of Kyoto. The emperor, whose predecessors had resided continuously in Kyoto for over one thousand years was leaving to establish his imperial court in Tokyo. The people lined the streets to bid him farewell, and many of them wept. No one was certain how the city would be affected by the departure of the court. Fortunately, Kyoto's energetic governor soon reassured his people. He built them Kawaramachi Street, an amusement quarter, as part of a promise to do everything in his power to maintain the city's vitality. This promise he kept, and Kyoto today is a city as lively and modern as any other in Japan.

Kyoto is not, however, merely a commercial city. Its natural beauty and great traditions have been celebrated over all its other attractions. From every vantage, the harmony of the city with its natural surroundings charms the eye: the green, gently sloping hills that enfold Kyoto and the houses, streets, and stores blend together easily. However, only with the effort of generations has Kyoto kept this harmony and its close touch with nature and the seasons.

Twelve hundred years have shaped Kyoto, so that wherever one happens to be in the city, one stands in the path of its history: patricians may have been driven in their ox carts by this spot; or samurai warriors may have hurried by there on their way to battle. From the moment a visitor arrives at Kyoto Station, history shadows him. There can be no better place than Kyoto to acquaint oneself with Japan's ancient past, for in Kyoto history is literally ever-present.

The following pages serve as an introduction to the development of the city, from its beginnings in 794 until the modern era, through culture, history, religion, and by a look at certain buildings and neighborhoods that best represent the major periods of its history.

In those early days of Japanese history, at a time when politics and religion were still inseparable, it was customary to move the entire capital, with all its palaces and residences, to another site on the death of an emperor, or at times of political disturbances or other serious defilements. By the eighth century, however, when Japan had developed into a centralized state headed by emperors, a more permanent capital was needed for stability. The wasteful custom of periodically transferring the capital was therefore abandoned.

However, the first "permanent" Japanese capitals before Kyoto proved to be quite otherwise. Nara was the capital from 710 to 784, and Nagaoka lasted only ten years, from 784 until 794. Emperor Kammu (r. 781–806) abandoned Nara for Nagaoka be-

cause the political power accumulated by the Buddhist temples became a threat to the state. But by moving the capital the emperor did not escape the struggle for political power. In Nagaoka the Fujiwara family, whose members had encouraged the emperor to abandon Nara, strove to consolidate its power and influence over him, and a number of important political figures fell victim in the process. In 785 the supervisor of construction was assassinated. Then Crown Prince Sawara, who was accused of having plotted against the supervisor, died mysteriously on his journey into exile. After that, death and illness in the imperial family and the nobility were invariably attributed to the vengeful spirit of the deceased prince.

The continuous misfortunes at Nagaoka induced the emperor to abandon the site and seek a new one. In the year 792 the emperor undertook a hunting expedition to the area which is now Kyoto. He returned to this area three more times. The twenty-second day of the tenth month (lunar calendar) of the year 794 was, according to the astrological charts, an auspicious day. On that day, Emperor Kammu declared, "The mountains and rivers are the collar and belt of this area and make it a natural fortress." With these words, he designated the site of a new capital, called Heian-kyō, or "Capital of Peace."

By calling the area "a natural fortress," the emperor was referring to a set of Chinese requirements by which all the so-called permanent capitals had to be laid out. A capital was to have three mountains, in the north, in the west, and in the east; two rivers to the east; and a lake or pond to the south. The pond, a necessary feature of a capital according to the Chinese, was a symbol of centralized power.

To allow a river to flow through and thereby divide a capital would have symbolized potential disunity of the nation. One of the first tasks, therefore, in laying out the new capital was to divert the rivers. The Kamo River once flowed through what is now Horikawa Street and met the Takano River south of their present confluence. Thus, large-scale works were required to prepare the land for the capital. The city was laid with its northernmost boundary at the present confluence of the Kamo and Takano rivers (just south of today's Imadegawa Street).

The new capital was rectangular in shape and measured three and a half miles from north to south and about three miles from east to west. It was slightly larger than Nara. The imperial enclosure—the palace and government buildings—which occupied approximately one-fifteenth of the total area, was built in the north-central part of the capital. None of its buildings has survived, yet the present Heian Shrine offers a fairly accurate, though reduced, idea of what some of these buildings were like. The main building of the shrine in the northern part of the grounds is a half-size copy of the Great Hall of State, whose southern gate also provided the model for the shrine's own southern gate. This shrine was built in 1895 to mark the 1,100th anniversary of the establishment of the capital and it enshrines the spirit of Emperor Kammu, in honor of whom the Jidai Festival is held every year on October 22.

Below Suzaku-mon (Red Bird Gate), the southern exit of the imperial enclosure, Suzaku-ōji (Red Bird Avenue) extended south, as Heian-kyō's main axis. It was about eighty yards wide, with willows planted on both sides. This avenue (which in modern Kyoto has shrunk to Senbon-dōri, or Thousand Willow Street) divided the capital into a western half and an eastern half. At the avenue's southern end stood another gate,

Rashō-mon. The huge dolphin finials soaring from the gate's gabled roof must have awed anyone approaching the capital. There were five steps on either side of the gate to slow all who passed through to a respectful pace.

The capital was further divided into nine east-west streets, numbered from north to south, with names ending in *jō*. Near Shichijō (Seventh Street), there were enormous market squares in both the left and right sectors of the capital. Aside from the food and other goods sold there, the markets were used for the punishment of criminals and even for the teaching of Buddhism. This may be why the Eastern Market has become the present Nishi Hongan-ji Temple.

To the east and west of Rashō-mon, the capital's main gate, stood two temples, Tō-ji (East Temple) and Sai-ji (West Temple). These were built at Emperor Kammu's behest to protect the eastern and western parts of the capital, and Emperor Kammu refused to have other temples built within the city limits. Sai-ji has long since disappeared, but Tō-ji still stands as one of Kyoto's most interesting and beautiful temples.

Enryaku-ji Temple
Despite Emperor Kammu's efforts to check the influence of Buddhism, he personally seems to have been a devout Buddhist. He maintained good relations with the priest Saichō (767–822) and encouraged him to build a temple on Mt. Hiei. This temple, Enryaku-ji, was to become the center of Tendai Buddhism, a new teaching Saichō brought from China.

Apart from Mt. Atago (3,031 ft.), the sacred Mt. Hiei (2,788 ft.) is the highest mountain in the vicinity of Kyoto and stands to the northeast of the city. The mountain's location is significant, since the northeast was feared as the "Devil's Gate," through which evil influences, epidemics, fires, and so on, were believed to spread. (Even today in order to ward off evil influence, the northeastern corners in many Kyoto houses, including the Imperial Palace, are cut off.) Like Tō-ji and Sai-ji in the southern part of the city, Enryaku-ji was built to protect the capital from evil. Malevolent forces were to be diverted by priests beating bells and continuously reciting magical incantations.

Saichō was the spearhead of a new school of Buddhism, which the temple on Mt. Hiei was built to promote. Born in 767 in a village near Lake Biwa at the foot of Mt. Hiei, Saichō studied Buddhism in Nara but retired to Mt. Hiei to find a deeper truth than any he could attain in the Nara temples. Even before the Heian capital had been established, Saichō built (in 785) a simple hut there for meditation. Three years later he was able to construct, with the help of a few disciples, a small monastery, later to be called Enryaku-ji, which he called Ichijō Shikan-in. *Ichijō* is the Buddhahood inherent in all human beings and *shikan* is a form of concentrated meditation through which this Buddhahood can be discovered. Saichō believed that each individual, whether patrician or peasant, had the means to attain Buddhahood. When the Ichijō Shikan-in was inaugurated in 794, the emperor himself climbed Mt. Hiei and set a precedent for many imperial visits to the mountain temple.

Saichō believed the end of the world was imminent, and decided that a unification of the various Buddhist sects was the only way to avert the apocalypse. To this end he was sent to China in 804 to study sacred texts, and returned the following year bearing scriptures to aid him in founding the Tendai sect.

Saichō died in 822 on Mt. Hiei. To the left of his grave there now stands a linden tree, the tree beneath which the Historical Buddha attained Enlightenment. To the right stands a sal tree, the tree beneath which Buddha died and entered Paradise. By thus arranging his grave, Saichō's disciples expressed their belief that their leader was indeed a reincarnation of the Buddha.

In 823, Emperor Kammu's successor, mourning the death of Saichō, granted him a great honor by renaming the temple Enryaku-ji. Enryaku was the official name of the reign period (782–806) during which the Ichijō Shikan-in had been built. He also gave Saichō the posthumous title of Dengyō Daishi, meaning "Great Teaching Master."

A statue of Yakushi, Buddha of Healing, said to have been carved by Saichō himself, is installed in Enryaku-ji's main hall, the Konpon Chū-dō. In contrast to ordinary temple architecture, this statue stands about ten feet below the outer floor from which worshipers offer prayers; the lowered inner floor allows them to come face to face with the Buddha. This symbolic descent of the Buddha to the level of mankind reinforces, by architectural means, the idea that the Buddha welcomes members of all levels of society. In front of the statue burns the so-called eternal light, first lit by Saichō in an act symbolizing the eternity of Buddhist teachings. The light is said to have burned continuously until 1571, when Oda Nobunaga, a powerful military leader, destroyed all the temples on Mt. Hiei and killed most of the priests. Ironically, the only structure left intact from the holocaust is a small pagoda behind the present Shaka-dō (Hall of the Buddha Shaka), a pagoda believed to be one of the pillars of the "Devil's Gate." Thanks to the reconstruction of Mt. Hiei's main temple halls from 1584, we can still enjoy the quiet solemnity of Enryaku-ji.

Along with the Buddhist temples, there exist in Kyoto the shrines of Shinto, a native religion of the Japanese. A full account of all aspects of Shinto would be a formidable task, so we will limit ourselves to what is essential to gain a better understanding of some of Kyoto's Shinto shrines.

Shinto (meaning "The Way of the Gods") worships a great number of local deities, among others, and those who live in the territory of a local deity can ensure the god's benevolence and protection only by regular and proper worship. Thus, during the annual Jidai Festival in October, residents of Kyoto worship the spirit of Emperor Kammu, the local and tutelary deity, at the Heian Shrine.

Mountain and river deities are other local Shinto gods of consequence to Kyoto. The deity of Mt. Atago protects the capital from fire; that of Mt. Hiei—enshrined at the beautiful Hiyoshi Shrine—is the guardian deity of Enryaku-ji. The deities of the Kamo River are worshiped in two of Kyoto's famous shrines, the Shimo-gamo (Lower Kamo) and Kami-gamo (Upper Kamo) shrines, and further up the river at the Kibune Shrine. Prayers against floods or for rain were often offered at these shrines by imperial representatives.

In Shinto, however, not only local deities but also the angry ghosts of deceased political potentates need special rites. It was believed that the spirit of a person who died as a result of violence, jealousy, or banishment would be restless and cause trouble. Since the degree of the spirit's malevolence depended on the dead man's rank and political ambitions, no evil spirit was more feared than that of a person of national importance, such as an emperor, an imperial prince, or a high-ranking minister, which

could cause disaster to the entire nation. This belief brings us to Kyoto's famous Kitano Shrine.

Kitano Tenman-gū Shrine

We have already seen the role belief in malevolent spirits has played in the decision to move the capital from Nagaoka to Kyoto. The Heian period (794–1185), however, had its own avenging ghosts, one of which is honored at Kitano Shrine. The restless spirits of several important political figures who were exiled and died in distant provinces were held responsible for subsequent epidemics, fires, floods, and droughts. Measures were taken to appease these spirits, for example by putting them to rest in beautifully arranged shrines and by overwhelming them with gay, showy festivals—that is, with something in marked contrast to their dark natures. During an epidemic in the capital in 863, such a festival was held in the imperial gardens and temporary shrines were erected for all six of the most feared spirits. Celebrants at the shrines offered flowers and fruits, recited sacred scriptures, danced, played court music, and presented pantomimes, acrobatics, and puppet plays. These spirits later increased to eight and were permanently enshrined at Kyoto's two *goryō* shrines. *Goryō* (august spirit) is the name given to these fearful spirits, and the festivals were called *goryō-e*, or festivals of august spirits.

Indeed, most of the festivals held in Kyoto today originated as celebrations honoring and appeasing evil spirits, including those of the Kitano and Imamiya shrines, as well as that of Mibu-dera Temple. The Aoi, Jidai, and Gion festivals, which attract thousands of tourists each year, also originated as *goryō-e*.

Kitano Shrine is one of the most famous shrines erected to appease an evil spirit. Its history goes back to the tenth century, when a series of disasters befell high-ranking aristocrats as well as members of the imperial family. In 909 the Minister of the Left, only thirty-nine, died during an epidemic. In 923 a prince died suddenly. In 930 the capital suffered floods, epidemics, and drought, and the palace was struck by lightning. Then the emperor fell ill and died. No one could identify the source of these misfortunes until 942, when a woman's dream resolved the question. The woman dreamed that the late Minister of the Right, Sugawara no Michizane, came to her and disclosed his desire to be enshrined at Kitano. Kitano was then a place of worship dedicated to the thunder god, who had been blamed for the damage inflicted upon the Imperial Palace. The woman's dream, which immediately became an object of general gossip, left no doubt that the spirit of Sugawara no Michizane and that of the thunder god were one and the same.

Sugawara no Michizane (845–903) had had a brilliant career on the basis of his learning, his abilities as a poet, and his political skills. When a new emperor came on the throne, however, his fortunes took a sudden plunge. He was accused of having plotted against the emperor's accession and exiled to the distant island of Kyushu, where he died unpardoned. For many decades thereafter, seemingly inexplicable evils beset the capital. After the woman's dream clarified their cause, a shrine was dedicated to Michizane's spirit at Kitano. In 959 the Minister of the Right enlarged the shrine because he was a descendant of the very person who had been instrumental in deposing Michizane, and whose own death, it was rumored, had been caused by Michizane's

vengeful spirit. Other measures were taken: Michizane's rank as Minister of the Right was posthumously restored, and in 993, during an epidemic, he was elevated to the still higher rank of Minister of the Left. When this proved inadequate, he was made Prime Minister. Imperial visits were made to the shrine, the first in 1004.

Kitano Shrine, then, is one of the most splendid in Kyoto, and is dedicated to Sugawara no Michizane, to the god of thunder, to literature and learning. It was therefore the site both for agricultural rites (thunder representing rain and thus fertility) and poetry meetings. Michizane's erudition is still remembered today in a small shrine within the precincts where students hang votive pictures for success in university entrance examinations.

It is generally agreed that the Heian period reached its height during the life of Fujiwara no Michinaga (966–1027), the uncontested patriarch of the Fujiwara clan. Ever since the capital had been moved from Nara, the Fujiwara family's rise to power had met little opposition, so that by the time of Fujiwara no Michinaga, the emperors had become mere figureheads and state affairs had turned into a Fujiwara monopoly. The Fujiwaras consolidated their power by consistently marrying their daughters to the emperors.

Michinaga's time also produced some of the best works of Japanese literature, for it was then that Lady Murasaki, herself a member of the Fujiwara clan, wrote her unsurpassed *Tale of Genji*. Michinaga's personality so much dominated his day that he is believed to have had a hand in deciding the arrangement of the fifty-four chapters that make up the novel and, according to a widespread theory, he may even have served as the model for the tale's hero, Prince Genji. Apart from its literary qualities, *The Tale of Genji*'s value lies also in the wealth of information it contains about the private and emotional life of Heian aristocrats. Through this tale we learn about their accomplishments in calligraphy, poetry, music, and painting, their rites of passage, marriages, superstitions, their social and political obligations, their appreciation of nature and the seasons, the role Buddhism played in their lives and, above all, their love affairs: relations with the opposite sex seem to have been Prince Genji's main preoccupation and most probably that of his society. Almost the entire *Tale of Genji* revolves around the prince's love affairs and the joys and sadness they evoked.

At that time relations between men and women, whether married or not, were relatively promiscuous: men could entertain a number of mistresses, and women, too, could have a number of lovers. Love affairs, however, were restricted by rank and kept secret in cases of lovers of different social status. Illicit affairs did happen, and if Prince Genji's affair with a lady of superior rank had not been discovered, he probably could have escaped exile. From examples in *The Tale of Genji*, love affairs usually followed a set pattern. A gentleman, for instance, hears about the beauty of a lady or catches a glimpse of her. His curiosity aroused, he has a poem delivered to the lady. After closely examining her suitor's poetic abilities and calligraphy, she might send him a favorable poem in reply, or if she finds fault, she might refuse him or make him wait, perhaps even going so far as one court lady, who forced her suitor to wait until he died. Should the answering poem be favorable, the suitor in turn carefully examines it, and if adequate, he will arrange to visit her at night at the first possible opportunity.

The way poems were so carefully examined shows how much of Prince Genji's

world was dominated by a quest for beauty and taste. Since the human body was not considered an object of particular beauty, people were drawn to each other by the graceful quality of their calligraphy, and their poetic or artistic skills. A simple gesture or a few words from a lady could be sufficient to arouse a man's passion. Both men and women considered a display of taste their most important asset.

The typical aristocratic Heian mansion consisted of a number of wings joined by covered passageways. Each wing consisted of a single, sparsely furnished room which could be divided into smaller units by tastefully arranged screens or curtains. When admitting a lover the lady would hide behind such screens where she could be seen only in dim outline, which probably accounts for the mystery in which the love affairs were usually enshrouded and for the occasional mistaken identity.

In all residential architecture the outside was as important as the inside. Light bamboo blinds that could be rolled up ensured open access to the garden and allowed the patrician to feel in close touch with nature and the seasons, a relationship of overriding importance as can be seen from the poetry, which is filled with references to the seasons and botanical metaphors.

Like Prince Genji, the powerful Fujiwara no Michinaga took life as a beautiful gift and enjoyed it to the fullest. At age forty-nine he wrote: "I have accomplished all that I could possibly desire," but qualified it with: "so long as I can continue as I am." In 1027, however, Michinaga was stricken with a fatal illness. He died ceremoniously at the temple he built, holding in his hands a string tied to the statue of Amida Buddha, to ensure access into Paradise. Michinaga's life symbolizes Heian culture at its zenith, but after his death the beauty and tranquillity of Heian civilization began to be disturbed by renewed struggles.

With Michinaga's passing the Fujiwara hold on the imperial family weakened and some emperors tried to revive genuine imperial rule. In 1086 an emperor abdicated in favor of his seven-year-old son and became a Buddhist priest. Nevertheless, he continued to hold the reins of actual power, thus establishing the system of "cloister government." The division thus created between a nominal (ruling emperor) and an actual (abdicated emperor) government split the nation into two factions, and the struggles which this division caused brought unprecedented violence to the capital. In the twelfth century, the streets of Kyoto were turned into a battlefield; the end of Heian was at hand.

The patricians used to believe that their own earthly existence belonged to a substage of Heaven, where people live in beauty and harmony. By the twelfth century, however, human life was more and more considered a province of Hell. The increasing attention given to the Buddhist theory of the end of the world and to the idea of Hell indicates clearly the despair of the times. Buddhist theory held that the period beginning 1,500 years after the death of Buddha would be an age of disorder, decadence, crime, and passion— in short, the end of the world. There were various conjectures as to the actual beginning of the apocalypse. The year 1052 was advanced as one possibility: during that year the capital was ravaged by bandits and fires, in addition to natural disasters. Capital punishment, which had not been inflicted for three hundred years, was reinstated. The apocalypse no longer seemed remote!

From these troubled times emerged two leading military clans, the Taira and the

The imperial
chrysanthemum emblem

Sugawara no Michizane's
plum blossom emblem

The paulownia emblem
of the Ashikaga shoguns

The hollyhock emblem
of the Tokugawa family

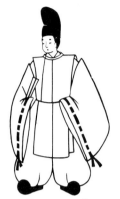

Heian period:
man's court costume

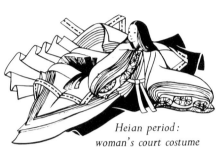

Heian period:
woman's court costume

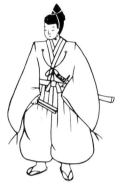

Kamakura period:
samurai's costume

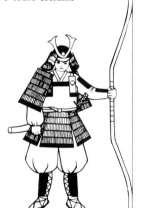

Muromachi period:
warrior's armor

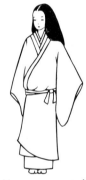

Momoyama period:
woman's costume

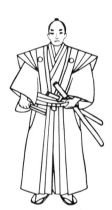

Edo period:
samurai's costume

Edo period:
townswoman's costume

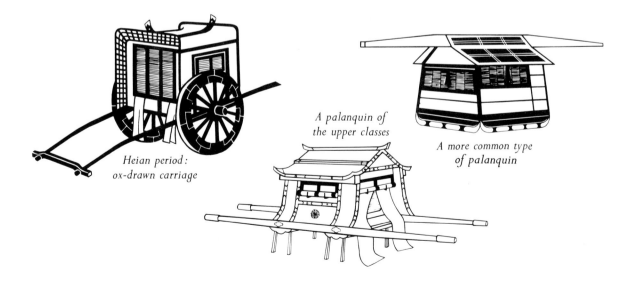

Heian period:
ox-drawn carriage

A palanquin of
the upper classes

A more common type
of palanquin

40

Minamoto. By the middle of the twelfth century imperial and aristocratic factions no longer used the military for their own ends; rather the military sought to usurp the government by preying on the weakened aristocracy. Once they seized power, the military factions fought among themselves for supremacy.

In the last battle of the Taira and Minamoto in 1185, most of the Taira, including the child emperor, were drowned or captured to be executed. Empress Kenreimon'in alone was saved and passed her last days at Jakkō-in, a nunnery to the north of Kyoto, praying for the fallen.

When the victorious Minamoto no Yoritomo established a military government in Kamakura, far to the east of the capital, Heian Japan faded to a memory and subsequent efforts to revive its glory all ended in failure. This transfer of the "executive" government away from the intrigues of the imperial court marked the beginning of a feudal period that was to last until 1868.

The end of the Heian period was a dark time but not entirely without its glimmers of light: faith in the mercy of the savior Amida Buddha shed some brightness on the spiritual life of the troubled nation. And just as the beginning of the Heian period saw the rise of outstanding religious figures such as Saichō, so the beginning of the Kamakura period (1185–1333) witnessed the emergence of new spiritual leaders.

Chion-in Temple
One of these was the priest Hōnen (1133–1212). When Hōnen was still a child, his father was attacked by robbers and mortally wounded. He called the young Hōnen to his deathbed and begged him not to seek revenge but to enter a monastery and pray, not only for himself but for the salvation of all mankind. Hōnen followed his father's bidding and dedicated himself to a life of service.

At the monastery, Hōnen's talents were quickly appreciated and he was sent with recommendations to Mt. Hiei for further studies in Buddhism. At the age of eighteen, however, he left Mt. Hiei to become a hermit and dedicated himself to the worship of Amida, faith in whom, Hōnen thought, would result in the spiritual reunification of Japan. The moral regeneration he sought could come about by rallying not only the members of the aristocracy behind his doctrine but the whole nation. With this in mind Hōnen moved to Otani, which had been a burial ground since the early Heian period. Here he taught that invocation of Amida's name was the best path to Paradise and that Amida's mercy reaches all people, regardless of their station in life. The site where he preached is marked by the Miei-dō (a hall which contains Hōnen's statue) in the Chion-in Temple, headquarters of the Pure Land, or Jōdo, sect of Buddhism that Hōnen founded.

Hōnen quickly acquired many followers among common people as well as disillusioned patricians. The powerful priests of Mt. Hiei, jealous of Hōnen's success, used their influence at court to have him banished from the capital, but Hōnen welcomed exile because it enabled him to teach Amida Buddhism to the simple people in the provinces. People like Hōnen, by proselytizing the teachings of Amida, brought the capital and the provinces closer together.

Hōnen was finally pardoned in 1211, at the age of seventy-eight, whereupon he reestablished himself in the capital. The following year he died while fasting at what is

now the Seishi-dō Hall of Chion-in Temple. As he lay on his deathbed, his followers wanted the dying man to hold a cord attached to the hands of a statue of Amida to ensure his entry into Paradise. Hōnen, however, refused, saying that he needed no such help for he could already see Amida and his attendants descending from Heaven on a purple cloud to guide him into the Western Paradise.

In 1227 the capital was again ravaged by fire, robbery, and assassinations, and Hōnen's disciples suffered for it. The monks of Mt. Hiei attributed these evils to Hōnen and burned down the temple that marked his teachings. They even attempted to vandalize his grave and throw his bones into the Kamo River.

The rebuilding of Chion-in in 1234 was sponsored by members of the imperial family and prominent military leaders, who kept it safe from wanton destruction, and its heyday came at the beginning of the seventeenth century, when it was officially recognized and gained an imperial prince for its superior. Chion-in as it stands today, however, represents not so much the period of its reconstruction, but the transition from the Heian to the Kamakura period in the twelfth century.

The dawning of the Kamakura period meant that Kyoto had lost all but nominal power. The military leaders at Kamakura made almost all important political and administrative decisions, decisions that the submissive emperor, under the strict surveillance of a military governor, was forced to ratify. This military government gave the warrior class power over the court aristocracy, thus bringing into Japanese politics and culture military values that differed sharply from those of Heian noblemen. Warriors believed in absolute loyalty to their superiors and the preservation of their honor, even at the cost of self-immolation. During the Heian period warriors had been discriminated against, not so much because they came from the countryside and were regarded as uncouth, but rather because they were considered inhabitants of Hell. To be born a warrior meant that one was condemned to commit violence, or die by it, as a result of evil committed in a previous existence. Coincidentally, it was not until the introduction of Amida Buddhism at the end of the Heian period that warriors were thought able to gain salvation. This new democratic and universal doctrine of salvation made possible the supersession of the aristocracy by the warrior class.

The events of the end of the Kamakura and the beginning of the Muromachi periods (1338–1573) well illustrate that changes in Japanese history were often brought about by the attempts emperors made to regain the power they had lost, first to the aristocrats, then to the warriors. We have seen the Heian period brought to an end by such a struggle; so, too, was the Kamakura. These imperial restorations often ended in failure simply because to regain total control, the emperors had to rely on military forces and, once successful, they were unable to strip their military allies of power. Consequently, these attempts merely effected a change in the nation's military leadership with no gain in imperial power.

With the help of Ashikaga no Takauji (1305–58), a warrior from northeastern Japan, Emperor Godaigo (1288–1338) was successful in bringing down the leadership of the Kamakura military government, yet he was unable to prevent Takauji from establishing his own hegemony, and thus failed to reestablish direct imperial rule. Both the emperor and Takauji stubbornly fought for the power they believed was theirs, and the struggle ended in bitter failure for Godaigo. In 1336 Takauji drove Godaigo out of the

capital and put another more tractable member of the imperial family on the throne.

This marks the beginning of incessant warfare and a sad epoch in Japanese history called the Period of the Northern and Southern Courts (1336–92). Godaigo escaped to Yoshino in the mountains south of Nara, where he set up a separate (Southern) court. The struggle between the Northern Court (at the capital) and the Southern Court at Yoshino continued until 1392, when the two sides came to terms.

Godaigo died in 1338 in Yoshino, holding the *Lotus Sutra* in his left hand and the imperial sword, a symbol of imperial power, in his right. In the same year, his opponent Takauji was appointed military dictator *(shōgun)* by the Northern Court and established his government in the Muromachi area of the capital, hence the Muromachi period of Japanese history. Fearing the vengeful spirit of Godaigo, Takauji ordered the erection of a temple in Arashiyama to the northwest of the capital, where Godaigo spent part of his youth. This was to become the splendid and spacious Tenryū-ji Temple, known for its beautiful garden.

The Muromachi period merged the warrior culture with the earlier aristocratic culture, and reached its height during the rule of the third military dictator Ashikaga no Yoshimitsu (1358–1408). In 1394 Yoshimitsu handed over the shogunate to his son and dedicated himself to Buddhism and the enjoyment of the arts. The refined culture of the Heian nobles appealed to him, and, although his family retained its political influence, Yoshimitsu turned sharply away from the militaristic tastes then in vogue. Artistic eclecticism brought imitations of Heian styles and refinements of warrior modes, which Yoshimitsu combined magnificently in the Golden Pavilion, built in 1397.

Kinkaku-ji (Golden Pavilion)
In purpose the Golden Pavilion imitated a Heian temple, the Phoenix Hall of Byōdō-in Temple in Uji, built in 1052 by the son of Fujiwara no Michinaga. Like his powerful predecessor, Yoshimitsu wished the Golden Pavilion to express his power, a power understood to transcend the temporal. Supported on pillars and extending over a pond, the Golden Pavilion conforms to descriptions of the Western Paradise of the Buddha Amida and illustrates the perfect harmony which should exist between Heaven and earth. By these devices, the Golden Pavilion, like other temples built by political figures, symbolizes legitimized political power—legitimized, that is, by heavenly mandate.

Yoshimitsu used the Golden Pavilion not only as a temple, but also as a place for conducting diplomacy and enjoying aesthetic pleasures. In 1408 a lavish reception that lasted twenty days was given there for the emperor. Days were spent with music, poetry, court football and archery matches, and entire nights with exotic food and drink.

The Golden Pavilion, named for the gold leaf covering it, reflects the eclecticism of the times. The first floor of the three-storied structure, as well as the surrounding garden, harks back to aristocratic architecture of the Heian period. The second floor is arranged like a temple hall mirroring warrior tastes, and the third is as bare as a Zen cell. A temple acolyte burned down the structure in 1950—an event recounted in Mishima Yukio's well-known novel *The Temple of the Golden Pavilion*—and the present pavilion is a recent reconstruction.

Once again such grandeur could not last forever. After Yoshimitsu, the Ashikaga military government began its decline, and power shifted gradually to the various feudal lords (or *daimyō*). The ensuing struggle to find a sufficiently strong successor to the Ashikaga wrought destruction not only in the capital but throughout the provinces. Kyoto was the center of the struggle mainly because of its symbolic significance as the seat of the emperor, without whose permission no government could claim legitimacy. Although the emperor had long since lost actual power to the various military clans, his position as spiritual leader remained vital.

Therefore, each political and military faction sought to occupy Kyoto, and those struggles in the years 1467–77 came close to destroying the capital. Entire neighborhoods were burned and laid waste, and the imperial palace, aristocratic mansions, and warrior residences were razed. The emperor moved to the present Imperial Palace (Gosho), where the damage had been less severe. These were Kyoto's darkest days. In 1500 an emperor died on the throne, too poor to retire, as was customary, before his death. His body was left unburied for six weeks until money could be found for his funeral. Emperors who succeeded him had to wait several years until funds could be raised to pay for their enthronement ceremonies. One emperor was reduced to selling his autograph as well as precious household utensils to eke out a living. If the emperors suffered this much, one can only imagine the degree of poverty that existed among the commoners. At last, however, one man prevailed and restored order to the troubled land. This was Oda Nobunaga (1534–82), who in 1573 drove out the last of the Ashikaga shoguns.

Yet it would be wrong to dismiss the late Muromachi period and label it merely a time of chaotic destruction, for it nurtured cultural traditions that have survived to this day. Even as Kyoto was swept by war and natural disasters, its artists continued to develop new art forms, and through them the city continued to play a role in the cultural life of the nation.

The new arts that became popular at this time were flower arrangement and the tea ceremony. The former had an indigenous source in the practice of offering flowers to the Shinto deities and to Buddhas. By the Muromachi period the art of arranging flowers became aesthetically refined, and a number of masters emerged. One of them, Ikenobō Senkei lived at Rokkaku-dō Temple. His expertise in the art resulted in the development of a specialized school of flower arrangement at Rokkaku-dō.

The art of flower arrangement came to be intimately associated with that of the tea ceremony. Tea plants had been introduced into Japan in the twelfth century by a Zen priest, and the brew was given to priests to prevent them from falling asleep during meditation. Tea was first planted at Kōzan-ji Temple, northwest of Kyoto, then in greater quantities at Uji, south of Kyoto.

Nōami (1397–1471) developed the preparation and drinking of tea into an artful ceremony. He devised the room in which tea can be both prepared and enjoyed. He formalized each movement, from the handling of the various utensils to the manner of drinking.

The tea ceremony is usually held in a single room, ideally a hut like a hermit's cell in the mountains. The floor is covered with rush mats, and there are no decorations other than a scroll and a flower arrangement. The guests enter by crawling through a small,

narrow doorway on their hands and knees, an act symbolizing the abolition of all social hierarchy during the ceremony. They try to forget their worldly concerns during the ceremony and attain a state of tranquillity and detachment, in which all their movements are gracefully slow, precise, and simple. No gesture, no motion is wasted in the ceremony's strict economy. The underlying spirit of the tea ceremony is Zen Buddhism, with its emphasis on restraint and simplicity. In this almost religious world of serenity, warriors sought a temporary escape from the cruel realities of their times.

The Ashikaga shoguns had been driven out, and Oda Nobunaga ruled effectively but ruthlessly. In 1570 when he entered the capital, he forced five men from each block to welcome him. When he needed stones to build a castle upon the ruins of the residence of the last Ashikaga shogun, he ordered that the heads be removed from stone Buddhas. When people in northern Kyoto refused to pay the taxes he demanded, Nobunaga had the entire quarter burned down. The most controversial of Nobunaga's deeds—and one that symbolizes the brutality with which he went about unifying Japan—was the 1571 destruction of the Tendai sect temples on Mt. Hiei. On that night the sky in the northeast turned a purplish red, which was for the people of Kyoto the true color of Hell. But Nobunaga's supremacy proved to be short-lived. When attacked and trapped in Kyoto's Honnō-ji Temple by one of his own generals in 1582, he committed suicide.

Toyotomi Hideyoshi (1536–98) succeeded Nobunaga; he was kinder to Kyoto and better liked by its people. He rebuilt most of the important temples, including Enryaku-ji, that were burned down during the disturbances of the latter Muromachi period.

In 1590 Hideyoshi practically rebuilt Kyoto on the model of the Heian capital, though the east-west streets in the southern part could not be reorganized according to the old plan. The north-south streets, however, were laid out according to the Heian plan, with the addition of one street, Teramachi (Temple Block). Recalling the reign of Emperor Kammu, who had allowed no temples within the city proper, Hideyoshi decided to concentrate "in blocks" the many temples that had sprung up in the city over the years—hence the appearance of temple districts such as Teramachi and Teranouchi.

Rebuilding Kyoto also meant fortifying it. In 1591 Hideyoshi ordered that a wall be constructed around the city for protection against flooding as well as hostile armies. Fourteen miles of walls were built; seven gates called *kuchi* (literally "mouth") and a number of bridges afforded communication with the provinces. Placenames in present-day Kyoto, such as Awataguchi, Tambaguchi, or Kōjinguchi are a reminder of these gates. One of the bridges was the Sanjō Ōhashi (Big Bridge of the Third Street), which marked the beginning of the road that linked Kyoto with the area of modern Tokyo. Hideyoshi's plans to fortify Kyoto included the construction of Jurakudai Castle, completed in 1586. Significantly, it occupied a part of the old Heian imperial enclosure.

Another of Hideyoshi's major construction projects was a huge Buddha at Hōkō-ji Temple (now behind the National Museum). In order to obtain enough metal to cast the one-hundred-fifty-foot Buddha, Hideyoshi ordered a general sword hunt. All privately owned swords, including those belonging to Buddhist priests, were confiscated in a campaign marked by the persuasive motto of "Give iron to the Buddha!"

A mere nine years after its completion, the Great Buddha was destroyed during an

earthquake in 1596. A copy was made in 1609, but further misfortunes beset the temple from the date the statue was unveiled. The huge bell of Hōkō-ji bears the inscription *Kokka Ankō*, meaning "Security and Peace in the Nation."

Daitoku-ji Temple

Japan's history at the end of the Muromachi and the beginning of the Edo period (1603–1868) is represented by Daitoku-ji Temple better than any other existing building in Kyoto. The temple had a close relationship with prominent military leaders and artists of the time, and in particular with the Zen sect of Buddhism.

In contrast to Hōnen's Pure Land sect, which relied solely on the saving mercy of Amida Buddha, the Zen sect actively tried to imitate the life of the Historical Buddha, Gautama. Gautama attained Enlightenment (a prerequisite for salvation and becoming a Buddha) by self-imposed hardships and discipline. Individual willpower and the practice of austerities mean more to Zen than the all-embracing mercy of Amida.

In Zen there is no canon. Words deceive; logic and metaphysics are illusions. Only introspection leads to Enlightenment, an enlightenment attained out of the spiritual vacuum left when conventional modes of thought are destroyed. Zen priests developed riddles as an aid to meditation and the creation of this vacuum. These riddles employ nonsense to exhaust the mind and to dismantle the framework of ego-consciousness. Examples of Zen sayings are: "Those who know, do not speak; those who speak, do not know," or "Not knowing how near truth is, people search for it far away, like the man who stands in water and cries for a drink."

Ever since Zen was introduced to Japan from China in the twelfth century, there has been a close relationship between its principles and those of the warrior class. Like Zen priests, warriors were stoics and ascetics, who sought a life not luxurious but simple. Fighting required concentration and meditation: the warrior had to do battle in a state of selflessness and he had to transcend the distinctions of life and death. Given this close association with the warrior class, it is not surprising that so many Zen temples were subsidized by members of it. Several smaller temples built on the grounds of Daitoku-ji are among those sponsored by military leaders of the time: Sōken-in, for instance, was built by Toyotomi Hideyoshi in memory of Oda Nobunaga, and Jukō-in was founded by a warrior of the Miyoshi family in memory of his father.

Jukō-in, however, is better known for the grave, located in its compound, of Sen no Rikyū (1520–91), the most celebrated and influential tea master of his time, who served first Nobunaga, then Hideyoshi. Rikyū emphasized classical restraint and humility, whereas Hideyoshi used the ceremony as a lavish and ostentatious display of luxury. (In 1587 for instance, Hideyoshi had Rikyū serve in a golden tea room he had built at Kitano Shrine.) The apparent disharmony in the tastes of the two is perhaps the reason Hideyoshi suddenly ordered Rikyū to commit suicide. It was at Jukō-in Temple of Daitoku-ji that Rikyū performed this act of self-immolation, but he is now remembered also in other buildings of Daitoku-ji: his statue adorns the second floor of San-mon Gate, and Kōtō-in has a room which once belonged to Rikyū's Kyoto mansion.

Another temple in Daitoku-ji, Daisen-in, enjoys a fame independent of the other important structures in the temple complex. The building itself has fine paintings by

great masters of the time, but it is the eastern garden, a Zen dry landscape garden with its stress on symbolism, which is best known. Rocks represent mountains, and sand water. Mt. Hōrai, a legendary island in the Eastern Sea inhabited by immortal sages, towers in the northeastern corner, a symbol of the oneness of Heaven and earth, happiness and suffering. A stream, representing the stages of life, flows from Mt. Hōrai. At first life races like a willful child, falling swiftly over the rocky bed of the future in a predetermined direction. Early in its course, the imaginary water, like impulsive youth, surges over and around the rocks. Soon various rocks present obstacles. One of them, "the tigerhead stone," represents the tragic aspect of life. It checks the stream of life, which eddies and whirls but must continue. The last rapids suggest human helplessness in life. The question of the meaning of existence emerges; the water is dammed up against a rocky wall, the wall of contradiction and doubt. The stream seems to stop here but flows over and continues. Beyond, the river is quicker and broader, representing the wealth the mind has acquired from experience. In the midst of this part of the stream is a rock, representing a boat loaded with the treasures of experience. Next to it a turtle tries to swim upstream, illustrating the futility of any attempt to return to the past. The stream continues. The southern end of the garden is empty. There are no more rocks, only sand. It is a world without form, like the spiritual vacuum, void of passion and thought and emotions. The white sand exemplifies the purity and complete freedom of the mind.

Another Daitoku-ji temple, Sangen-in, symbolizes the end of one era and the beginning of another, for it is the grave of Ishida Mitsunari (1560–1600), a powerful feudal lord. Mitsunari was first a follower of Hideyoshi, who recognized in him a man of great talent. After Hideyoshi died in 1598, leaving a child to succeed him, Mitsunari served as one of the child's regents. Yet among the regents Hideyoshi had appointed to keep his family supreme was another feudal lord, Tokugawa Ieyasu (1542–1616), in whom Mitsunari soon found a formidable rival. Ieyasu's son contracted a marriage that Mitsunari feared would directly threaten Hideyoshi's family, and he began raising troops against Ieyasu. The decisive clash between them occurred on October 21, 1600, at Sekigahara (a village between Kyoto and the present city of Nagoya). By the evening of that day Ieyasu emerged as the victor. Ishida Mitsunari was beheaded on November 6 and his head exposed on the dry bed of the Kamo River.

The battle of Sekigahara decided the fate of Japan for the next two and a half centuries. After Tokugawa Ieyasu had eliminated the last of Hideyoshi's family, and a rebellion of Christians in Kyushu was subdued in 1638, Japan was at peace again.

In 1600 the military government had been transferred once more away from Kyoto to Edo, present-day Tokyo. Kyoto was left in the hands of a military governor whose duty consisted in keeping a check on the temples, the patricians, and particularly the emperor.

Nijō Castle
The Kyoto residence of the military governor was Nijō Castle, which, with its moat, massive walls, and heavy gates, must have made an intimidating impression on the citizens of Kyoto. Built in 1603 by Tokugawa Ieyasu, it incorporated parts of Hideyoshi's Kyoto residence to signify the transmission of power from the Toyotomi to the

Tokugawa family. It was at Nijō Castle that, in 1603, the emperor bestowed upon Ieyasu the title of shogun, which was to remain within the Tokugawa family until 1868.

Castles with moats and high stone walls and the firearms that made such fortifications necessary were both introduced by Europeans. Portuguese voyagers who had lost their way and accidentally discovered Japan in 1542 brought important changes to warfare and castle building. Nijō Castle, however, was not built to resist the onslaught of a large army, but to stand for the continuation of military rule in Japan.

The structure of the castle faithfully reflects the social hierarchy and military alliances of the Edo period (1603–1868). The Ninomaru Goten, an audience hall, consists of five halls connected by passageways or covered corridors. Each hall was built on a different level, so that the higher one stood in society, the closer one approached the shogun's quarters. The paintings and carvings on the walls separating the various parts of the building are consistent with the hierarchical plan of the whole: the art work in the inferior reception halls is less vigorous than that in the more important ones.

The garden to the west of Ninomaru Goten was laid out in preparation for the emperor's visit in 1626. The garden was designed to impress him with the strength and permanence of the shogunate, and originally contained no elements which might indicate the change of the seasons. The pond has three islands: the Crane and Turtle islands symbolize longevity; and Mt. Hōrai represents eternal bliss.

Ieyasu and his immediate successors used to visit the castle to flaunt their power. After 1634 a show of power was no longer necessary, with the nation firmly in the hands of the Tokugawa shogun, and visits were discontinued for 229 years. From 1863 on the castle came to symbolize imperial rather than Tokugawa power. That year, having been unable to prevent Commodore Perry's visit, the fourteenth shogun was summoned to Nijō from Edo to be reprimanded. The fifteenth and last shogun spent most of his term at the castle. What had once been the ultimate symbol of Tokugawa power swiftly became the symbol of Tokugawa defeat when, in 1867, the last shogun surrendered the government to the emperor at Nijō Castle, signaling the end of two and a half centuries of Tokugawa military government and the beginning of Japan's modern century.

When the emperor left Kyoto in 1869, the people feared that the city would become a second Nara, a museum of antiquities. Kyoto, however, adapted remarkably well to the industrialization and modernization that swept Japan from the Meiji period (1868–1912) on. Yet behind this facade of modernization hides a stubborn determination to preserve traditional values and lifestyles, to retain the past and to transmit it to the future.

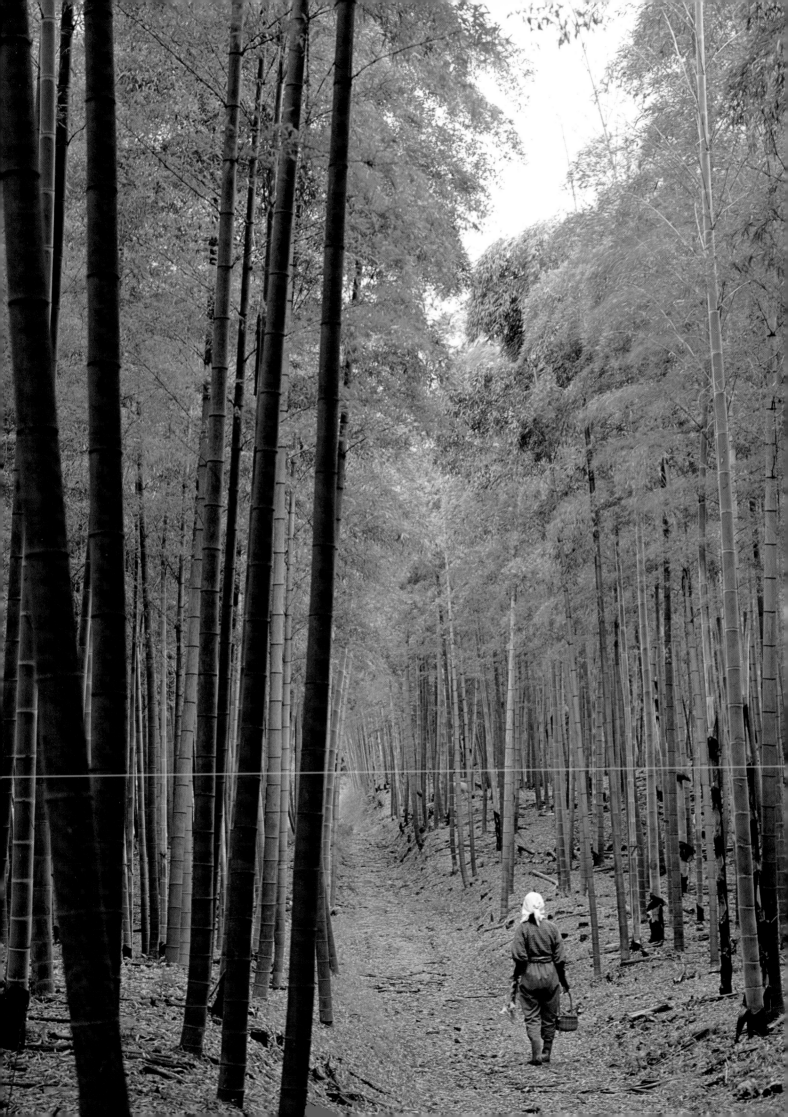

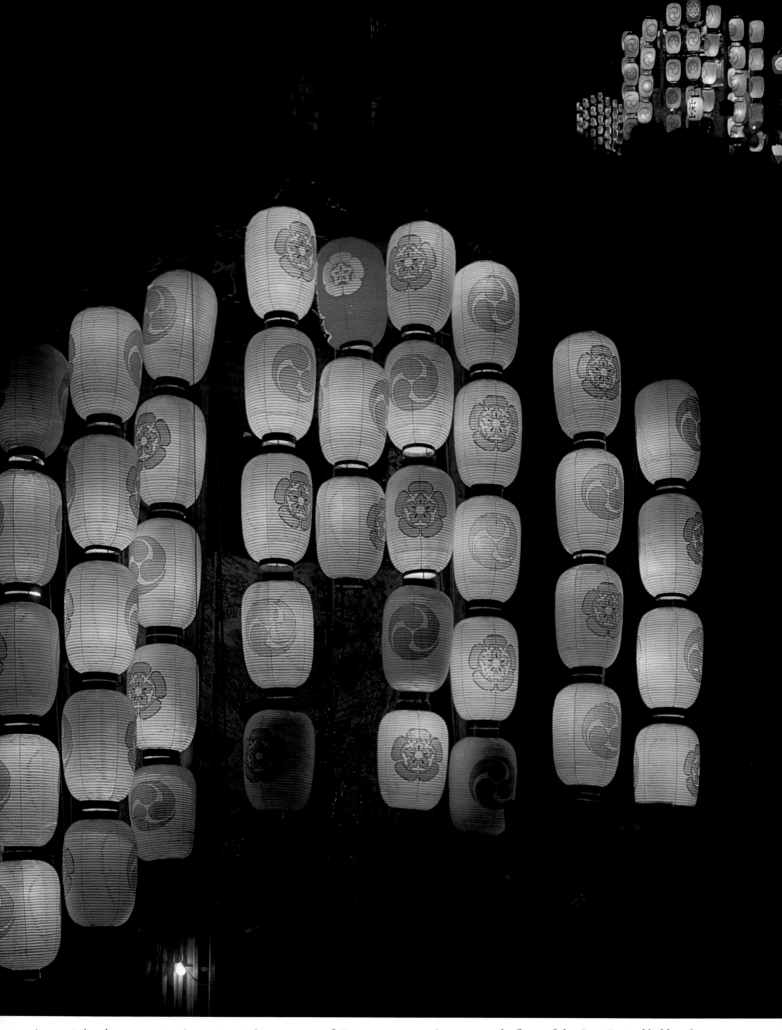

32. A bamboo grove in the spring at Sagano, west of Kyoto. 33. Lanterns on the floats of the Gion Festival held in the summer.

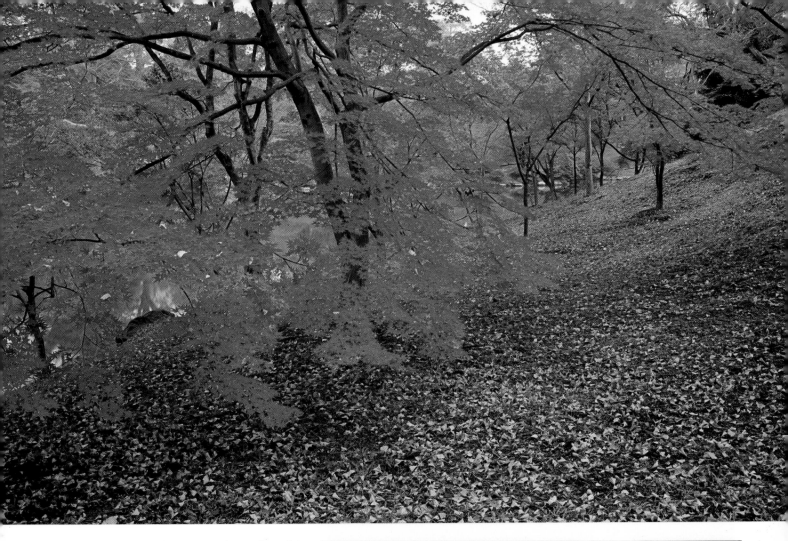

34. In the fall the maple trees in the garden of the
Imperial Palace turn a vivid red.

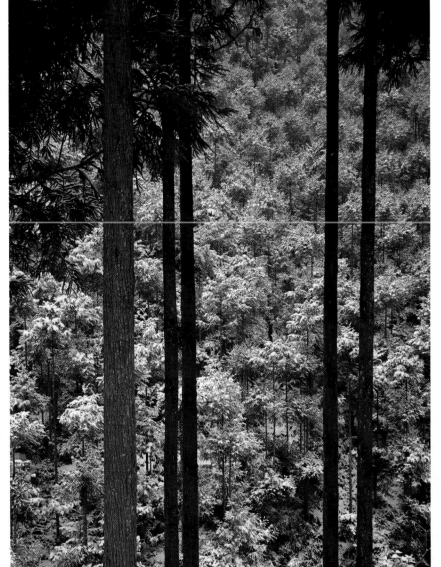

35. Snow covers the cedars on Kyoto's northern
hills in winter.

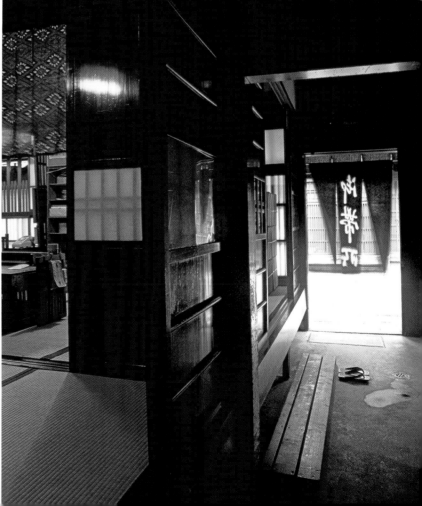

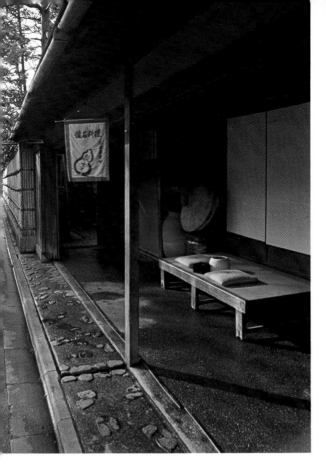

36–41. The following plates show some of the best examples of typical merchant houses in Kyoto. *Above left:* The seventeenth-century tea house "Sumiya" is often compared to the Katsura Imperial Villa for its harmony and simplicity. *Far left:* The entrance to an *obi* (sash) shop, with the name of the shop written on the curtain. *Left:* The interior of the same shop is like a private house with an elevated tatami room; items for sale are not displayed but brought to the customer on request. *Above left:* This roadside tea house is simply marked by a gourd sign; the extended eaves are typical of Muromachi-period shop architecture. *Above right:* The symmetry and simplicity of the latticework on fences, doors, and windows are the pride of Kyoto houses. *Right:* A narrow alley in the Gion district is bordered by high bamboo fences.

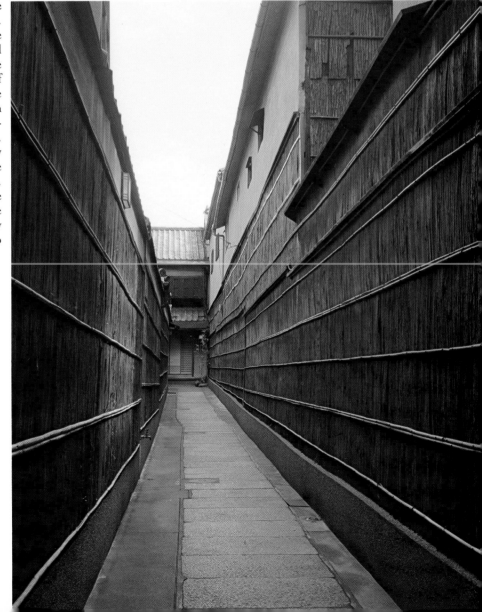

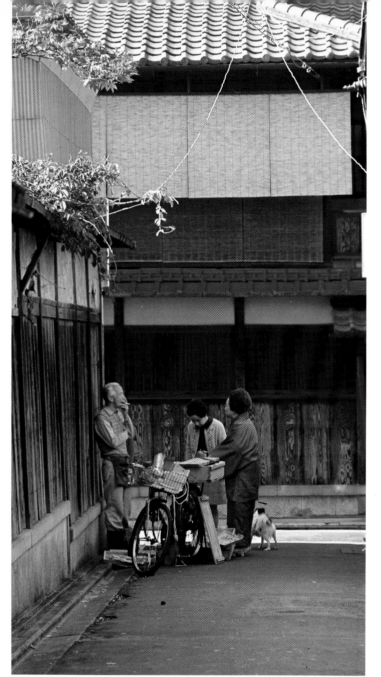

42. Chatting at a street corner in the Gion district, where the houses have high walls and bamboo blinds over the windows.

43. There are over one hundred stalls at Nishiki Market, offering every type of food.

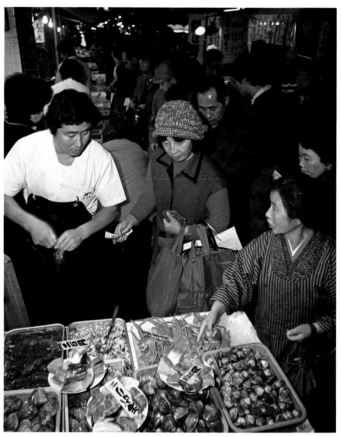

44. The market at Tō-ji Temple is held on the twenty-first of every month to commemorate the death of Kōbō Daishi, head priest of the temple in the ninth century.

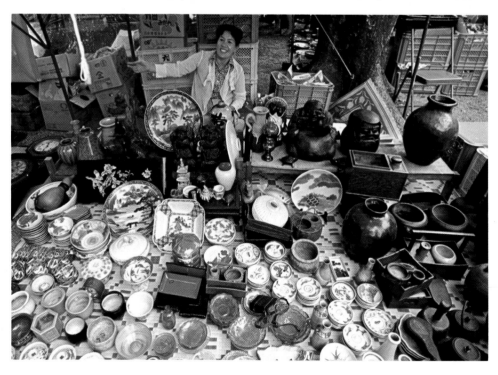

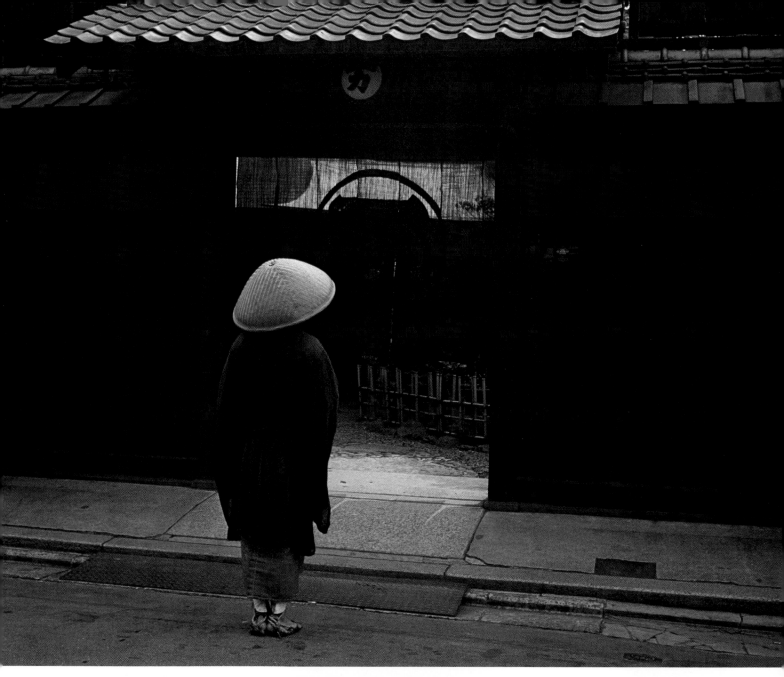

45. Begging is part of every priest's training:
here a Zen priest begs at the door of a Kyoto
tea house.

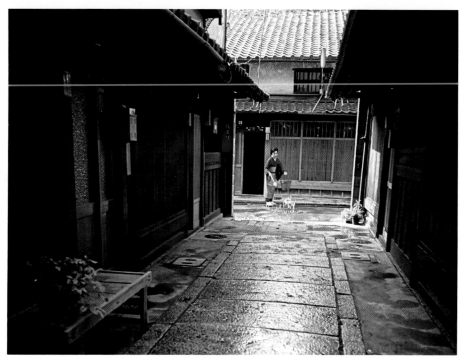

46. A woman sprinkles the path in front of
her house with water to prevent the dust
rising in the summer heat.

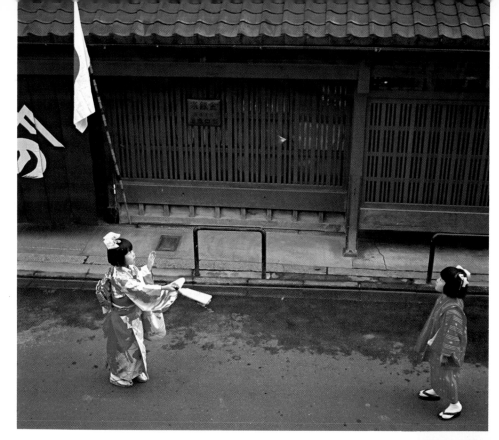

47. Two colorfully dressed girls play battledore and shuttlecock outside a typical Kyoto house at New Year's.

48. Two women getting sacred fire from Gion Shrine with a string of straw to cook the New Year's dishes.

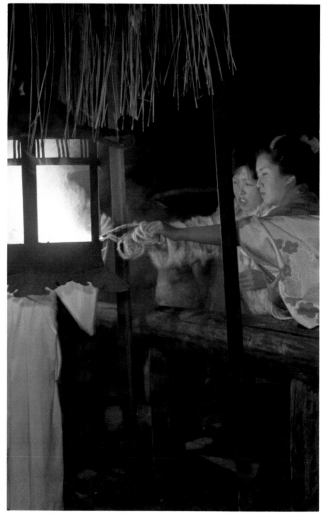

49. Boys and girls pass around a prayer string during the Bon Festival to pray for children who suffer in Hell, while the priest recites a sutra before an altar.

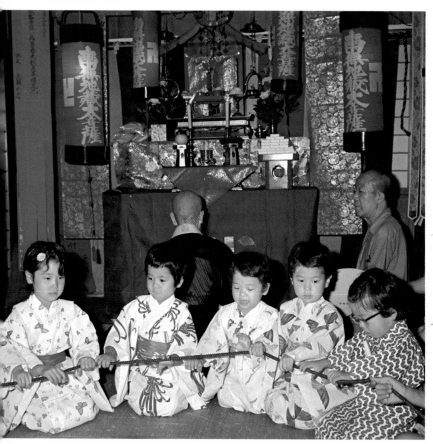

50–52. Doll manufacturing is one of the city's traditional crafts. The dolls are made of molded wood powder and glue, and the cheeks and noses are added by hand. *Left:* After much sanding and polishing, the dolls are painted. *Below left:* The dolls' hair is dressed in traditional styles. *Below right:* A completed doll in a brocade kimono.

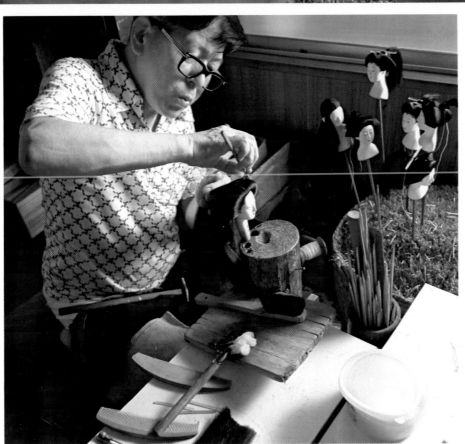

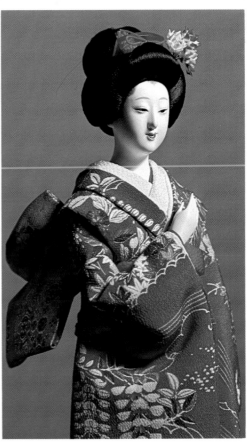

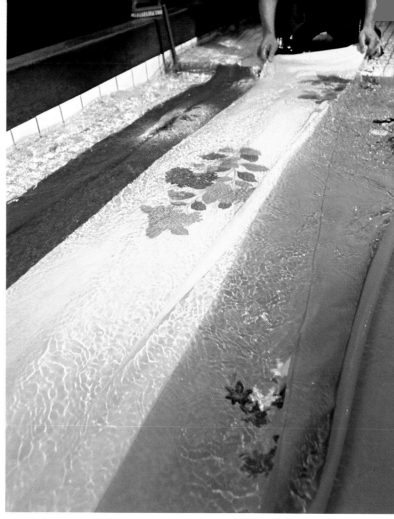

53. In *yūzen* dyeing, the design is cut into paper to make a stencil. This is then laid on the fabric and colors are applied.

54. The dyed material is washed to remove glue and excess color. Dyers now use their own tanks instead of washing the fabric in the Horikawa River as they did in former times.

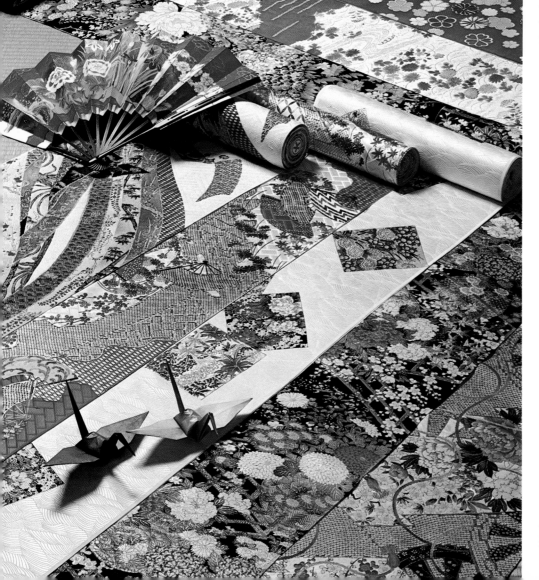

55. Finished rolls of *yūzen* material, with traditional designs of flowers, fans, and patched brocade. One roll is enough to make a kimono.

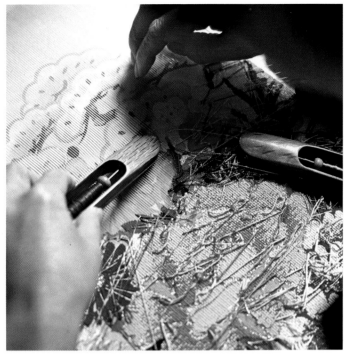

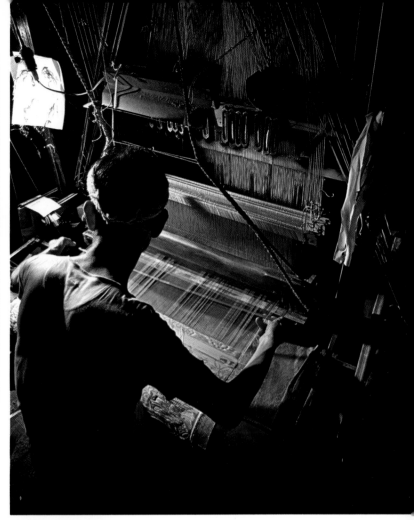

56. In weaving Nishijin brocade, the threads of the warp provide the design.

57–59. *Above:* A priestly garment is being woven on a Nishijin loom. *Left:* Traditional Nishijin designs usually allude to the seasons. *Below:* A contemporary design in Nishijin brocade on a kimono sash.

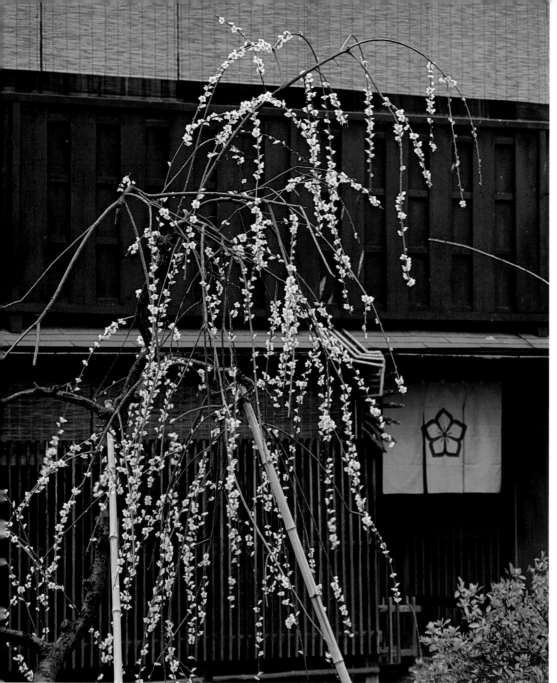

60. Plum blossoms bloom in early spring along the Shirakawa River in Gion.

61. A *maiko* (apprentice geisha) leaves for a party at New Year's.

62. The interior of the "Ichiriki" tea house in Gion shows a traditional room with an alcove (*tokonoma*), shelves, and a small adjoining garden.

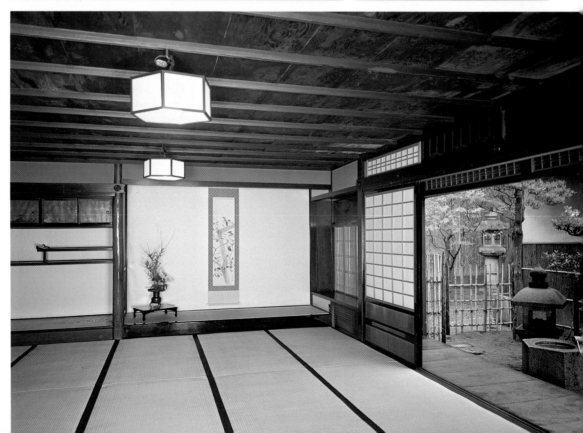

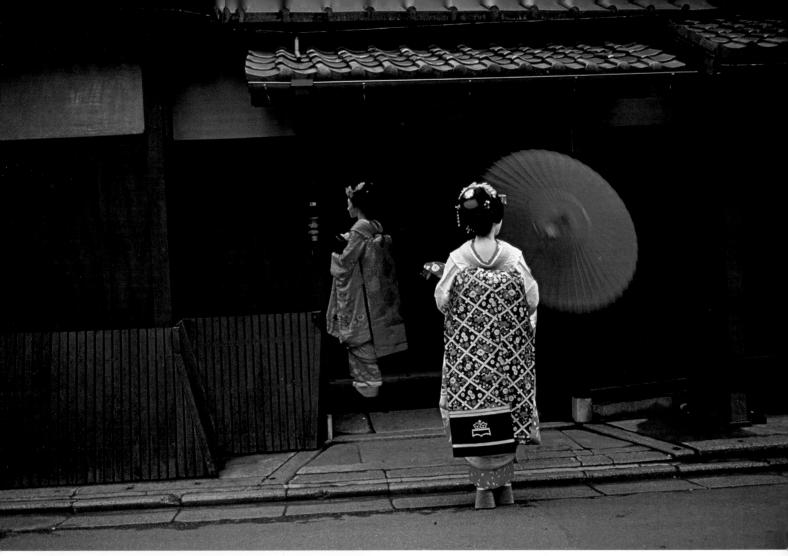

63, 64. *Maiko* girls in Gion are distinguished by their colorful, long sashes. *Left:* A geisha in traditional coiffure is dressed in formal black kimono for New Year's.

65. A performance of *Miyako odori* (Kyoto dances) is given every year in spring by the *maiko* and geisha of Kyoto.

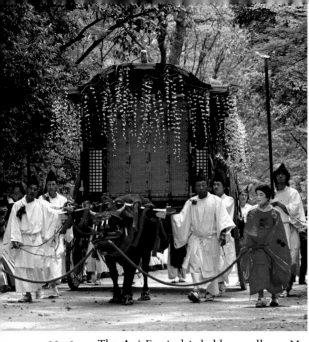
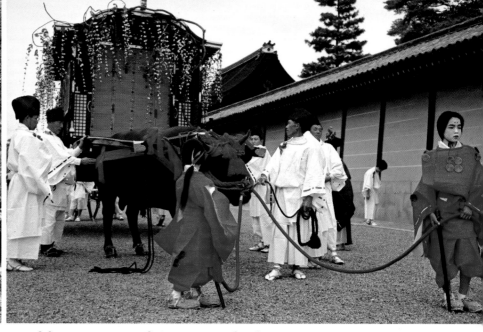

66, 67.　The Aoi Festival is held annually on May 15 and features seasonally decorated ox-carts. *Left:* Ox-carts were the principal means of transportation for the aristocracy. *Right:* The ox-cart passes by the Imperial Palace.

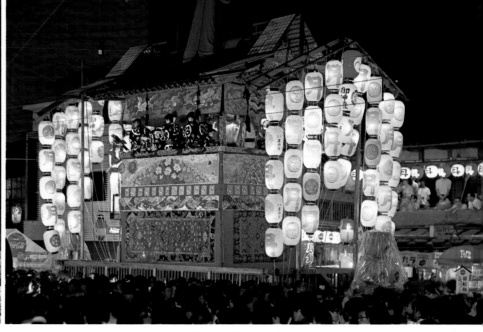

71, 72.　The Gion Festival is held throughout July and it is considered to be the principal festival of the city, drawing thousands of visitors annually. *Left:* A display of paper lanterns. *Right:* A float symbolizing the moon.

75, 76.　The Jidai Festival takes place on October 22 and features a procession representing the various periods of history. *Left:* A shogun's messenger and his retinue of the Tokugawa period. *Right:* Early Kamakura warriors.

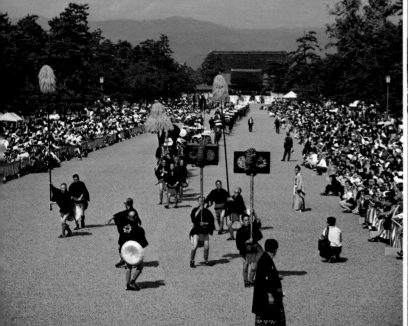
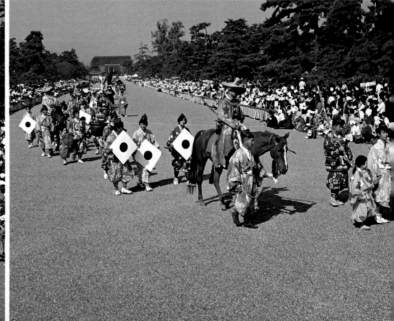

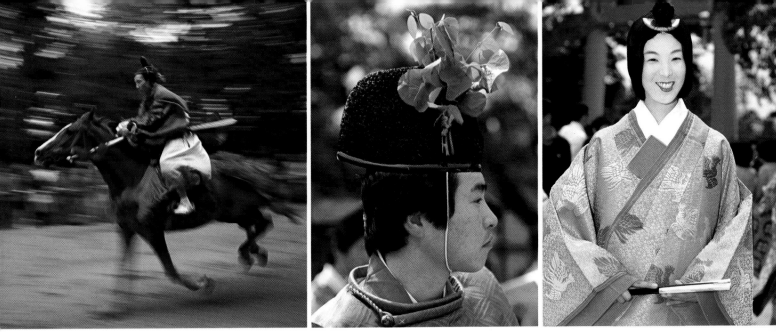

68–70. The Aoi Festival. *Left:* Horse-racing at Kami-gamo Shrine. *Center:* A man in a traditional nobleman's hat decorated with hollyhock (*aoi*) leaves. *Right:* A lady wearing court costume.

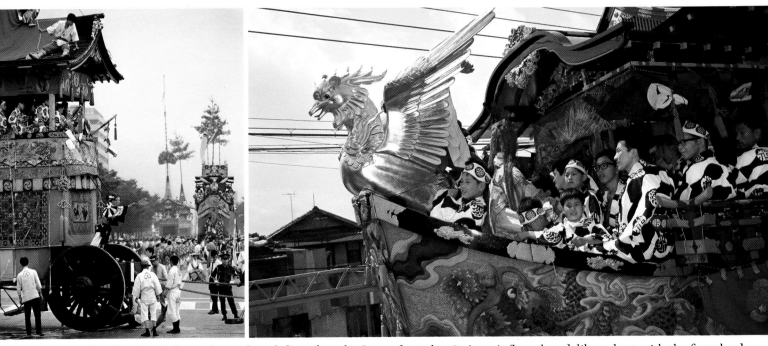

73, 74. The Gion Festival. *Left:* A float dedicated to the Sun Goddess, drawn through the city streets at the height of the festival. *Right:* A float shaped like a boat with the figurehead of the God of the Sea.

77–79. The Jidai Festival. *Left:* A noblewoman dressed in the traditional twelve-layered kimono of the Heian period. *Center:* A female warrior of the Heian period. *Right:* A woman in sixteenth century costume.

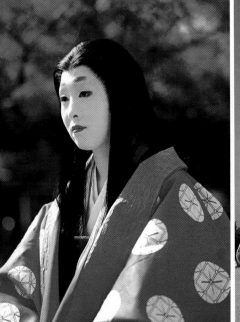

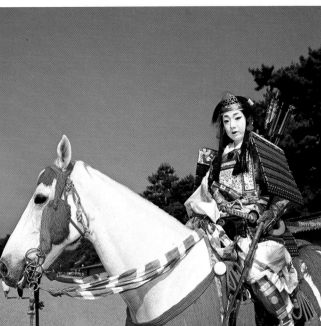

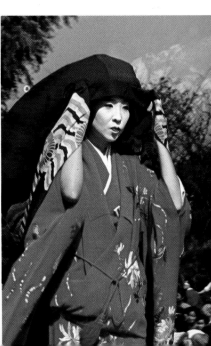

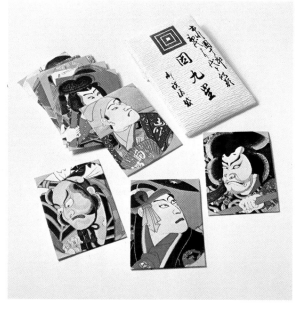

80. Painted fans, a traditional craft.　　81. Kabuki actors on gift-wrapping paper.　　82. Small dolls made of Kyoto paper.

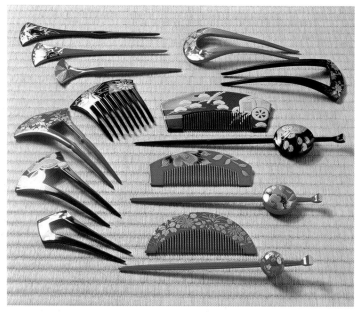

83. Hair accessories used in traditional Japanese coiffure.　　84. Traditional Kyoto make-up tools and rouge.

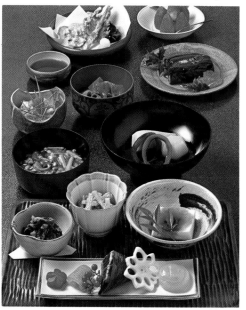

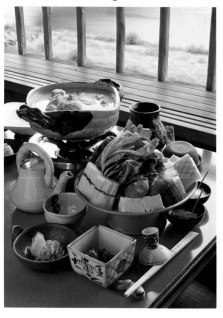

85. Various Kyoto confections.　　86. Vegetarian Buddhist dishes.　　87. Chicken and vegetable hotpot.

KYOTO TODAY

THE FESTIVALS

Kyoto bears the extremes of the seasons. The summers are hot and humid and the winters can be so bitterly cold that the people of Kyoto believe that "the cold comes out of the ground." Since the city's foundation, the seasons have played an important role in the daily lives of the people. In early spring when the plum trees bloom, people go to Kitano Shrine to greet the first blossoms of spring. When the cherry blossoms follow, they flock to the parks and temple gardens with food and drink to enjoy the ephemeral beauty of spring. In so doing they emulate the Heian-period nobles, who admired the blossoms and enjoyed them together with food and drink, poetry, music, and dance. In summer people listen to the singing of the crickets and watch the fireflies as they weave through the darkness of the warm nights. In fall they view the beautiful crimson leaves at places like Arashiyama. The people enjoy winter too, and there is no greater pleasure than visiting a quiet mountain temple on an early winter morning when the temple seems to be slumbering under the snow that has fallen overnight. The changes of the seasons have given the people an acute sense of the passage of time and the transience of human existence. These they have often compared, in their poetry, to the fragile beauty of the cherry blossoms, the short life of the cicada, or to autumn leaves which are at the mercy of the wind.

The seasons have yet another dimension. The festivals of each season bind the people of Kyoto to the history of their city no less than do old temples and shrines. Numerous festivals have been held each season, year after year, for over a millennium.

The New Year begins with the echo of the bell of Chion-in Temple and with a visit to Gion (Yasaka) Shrine. On February 3, the last day of winter according to the lunar calendar, people banish winter at Yoshida Shrine, Imamiya Shrine, or Rozan-ji Temple. They chase demons away by shooting arrows, throwing beans, and by shouting the words: "In with good fortune, out with the devils!" March 3 is Girls' Day, when families who have girls display Hina dolls in their homes to ensure their daughters' future happiness. In other spring festivals, comic pantomimes are performed at Mibu-dera Temple, and horse-racing, an old custom dating back to Heian days, takes place at Kami-gamo Shrine.

Summer follows the rainy season, and in mid-July people dressed in colorful cotton *yukata* gather in the city center to watch the Gion Festival floats and to hear the festival music played on them. In mid-August the Bon Festival honors the souls of the dead, believed to come temporarily back to earth. The autumn Jidai Festival honors Emperor

Kammu and allows the people to watch a procession of men and women dressed in costumes dating from the Meiji Restoration of 1868 back to the times of Emperor Kammu himself—a complete review of Kyoto's history and culture. On the same day comes the mysterious Fire Festival of Kurama, when young men carry huge burning torches through the streets. Winter begins in December with the *kaomise*, a three-hundred-and-fifty-year-old tradition during which Kabuki actors display their art and Kyoto women vie with each other in the splendor of their kimono.

Given the importance of the seasons and their festivals in the lives of the people of Kyoto, at least two of the most important ones, the New Year and the Bon Festival of August, should be closely examined.

New Year festivities in Kyoto are celebrated not only on January 1 but as early as December 13. On that day *maiko* girls (apprentice geisha) go to their dancing teacher's house to offer her round cakes made of pounded rice. They receive in return a fan used in the dances which the *maiko* perform to entertain their guests. On that day one can see the girls walking through the old, narrow alleys of the Gion district, wearing traditional clogs *(geta)* and long-sleeved kimono with dangling *obi* sashes. On this day also, in preparation for the New Year, people begin cleaning their houses—a cleansing that reaches its height when a crowd of the faithful gather to clean and dust the huge Nishi (Western) and Higashi (Eastern) Hongan-ji Temples.

On December 21 and 25 two important markets open, offering everything from kitchen utensils to antiques. The first, called Shimai-Kōbō, is at Tō-ji Temple, marking the last monthly services of the year, held to commemorate the death of Kōbō Daishi (he died on a twenty-first), head priest of Tō-ji at the beginning of the Heian period. The second, called Shimai-Tenjin, is held at Kitano Shrine to mark the last monthly celebration of the death of Sugawara no Michizane (he died on a twenty-fifth). Here, among other things, they buy pickled plums *(umeboshi)*, a product of the famed plum trees of the shrine, to be used in the New Year's *Daifuku* (Great Happiness) Tea.

For the different New Year's meals a variety of special foods is eaten. After December 25 people begin pounding rice to make *mochi*, or glutinous rice cakes, the most important food item on a New Year's table. The round *mochi* are given to relatives and friends; two of them are also offered at the house altar (where the family's ancestral spirits are enshrined), and another two displayed in the alcove *(tokonoma)*.

Since the market squares of the old Heian capital have long since disappeared, the only old market left in Kyoto is at Nishiki Kōji, a short street between Teramachi and Takakura streets. This has existed since the times when Hideyoshi rebuilt the capital in the latter half of the sixteenth century. In olden days, thanks to a stream running underneath the street, fish could be kept fresh (remember Kyoto is at a distance from the sea) in containers under the water. Over one hundred stalls line Nishiki Market, selling most ingredients needed for the New Year's dishes—fresh and smoked fish, dried seaweed, pickled vegetables, crabs, shrimp, eggs.

On New Year's Eve the people of Kyoto customarily eat soup noodles *(soba)*, due to the traditional belief that the long noodles will grant them longevity. After the *soba* they must bring a new flame for the kitchen hearth, since New Year's dishes must be cooked with fresh and sacred fire. Housewives braid straw into a string, light it at sacred bonfires set in a number of Kyoto's shrines, notably Gion Shrine, and hurry

home, whirling the string around continuously to keep the fire alive. Nowadays this custom, called *okera-mairi*, is disappearing because kitchen fires have been replaced in most Kyoto houses by electric and gas cookers.

When midnight approaches people dressed in kimono go out again to hear Kyoto's temple bells ringing out the old year. Among the most famous are those at Jingo-ji and Mii-dera temples. However, the one that attracts the largest crowds is that at Chion-in Temple, Japan's largest bell (165,000 pounds). Shortly before midnight over twenty young priests strike the bell 108 times at regular intervals with the end of a great log. According to Buddhist belief, a man is likely to have committed 108 sins during the year, so by ringing the bell as many times, all sins are expiated and the New Year can begin immaculate. On the last stroke of the bell, the New Year begins.

Before dawn on New Year's Day, a mysterious play takes place on the stage in front of the main sanctuary at Hiyoshi Shrine. Two actors perform a dance; the one in long, white hair perhaps personifies the old year and the one in black, the New Year. From these plays, called *okina*, the Nō theater is considered to have originated.

Later that morning people offer prayers for a happy and prosperous year at Gion, Kitano, or Heian shrines. All members of the family from grandparents to the smallest children participate, which is why people who live far away from their families usually return home for New Year's. One sometimes sees, mingling with the usual crowd, a geisha with the traditional *taka-shimada* hairstyle, decorated with rice-ears, wearing a kimono which, with the exception of a design around the hem, is entirely black.

To ensure a happy New Year, people eat a set of special dishes called *osechi*, consisting of, among other things, black beans, fish cake, egg rolls, fish cooked in sugar and soy sauce, and rolled seaweed, all beautifully arranged in square lacquered boxes. An important additional dish is called *o-zōni*, which consists of pounded glutinous rice *(mochi)* boiled in soya bean paste *(miso)* soup flavored with radishes and fish flakes. Before eating *o-zōni*, however, the family offers a bowl to the household shrine. Then they drink the "Great Happiness Tea," a salty tea made with pickled plums.

The other festival for which the Japanese try by any means to return to their homes is the Bon Festival, which marks the beginning of the year's second half (according to the lunar calendar) and is the time when the souls of the dead are believed to temporarily return to earth. During their return, these souls have to be welcomed, entertained, and properly sent back—three stages which provide the highlights of the Bon season. Since the Heian period, people have visited cemeteries at the beginning of the Bon season to welcome the returning souls and to take them home to be entertained for a week before being sent back, and in Kyoto practices and custom prescribe the ways of doing this.

The Bon Festival begins on August 8 with a visit to Chinkō-ji Temple. The location of Chinkō-ji (also called Rokudō-san) marks one of the largest grave areas that has existed since Heian times. Formerly, it extended from Kiyomizu-dera Temple all the way downhill to the Rokuharamitsu-ji Temple and as far north as Chion-in. The location of a graveyard in that area of the capital is based on the belief that souls inhabit mountainous regions. People saw Paradise on top of mountains and Hell at the foot of mountains or at the bottom of valleys and ravines. This may be why around Kyoto there are valleys called "Valley of the Condemned," and mountain peaks are named

SOME PRINCIPAL FESTIVALS AND OTHER EVENTS

DATE	FESTIVAL/EVENT	LOCATION
JAN. 1–3	HATSUMŌDE (The first visit of the year to a shrine)	Gion Shrine and other shrines
JAN. 14	HADAKA ODORI (Naked Dance)	Hōkai-ji
FEB. 2–4	SETSUBUN ("Change of Season")	Temples and shrines
FEB. 25	BAIKA-SAI (Plum Blossom Festival)	Kitano Shrine
MARCH 3	HINA MATSURI (Dolls' Festival)	Hōkyō-ji
APRIL 1–30	MIYAKO ODORI (Kyoto Dances)	Gion Kaburenjō Theater
APRIL (2nd Sunday)	TAIKŌ NO HANAMI GYŌRETSU (Cherry Viewing Procession)	Daigo-ji
APRIL (2nd Sunday)	YASURAI MATSURI	Imamiya Shrine
APRIL 21–29	MIBU KYŌGEN (Pantomimes)	Mibu-dera
MAY 15	AOI MATSURI	Kami-gamo and Shimo-gamo shrines (procession starts from Imperial Palace)
MAY (3rd Sunday)	MIFUNE MATSURI (Boat Festival)	Arashiyama Park
JUNE 1–2	TAKIGI NŌ	Heian Shrine
JUNE 20	TAKEKIRI-E (Bamboo-cutting Ceremony)	Kurama-dera
JULY 1–29	GION MATSURI	Throughout Kyoto
AUG. 7–10	TŌKI MATSURI (Pottery Festival)	Gojōzaka
AUG. 8–10	MUKAE-GANE	Chinkō-ji
AUG. 16	DAIMONJI GOZAN OKURIBI	Spectacular bonfires are lit on the five mountains around Kyoto
AUG. 16	TŌRŌ NAGASHI (Floating paper lanterns)	Arashiyama Park
AUG. 25	ROKUSAI NENBUTSU ODORI	Kisshō-in Shrine
SEPT. 22 or 23	SENTŌ KUYŌ	Adashino Nenbutsu-ji
OCT. 22	JIDAI MATSURI	Heian Shrine (procession starts from Imperial Palace)
OCT. 22	KURAMA NO HIMATSURI (Fire Festival)	Yuki Shrine
NOV. (2nd Sunday)	MOMIJI MATSURI (Maple Festival)	Arashiyama Park
DEC. 1–26	KAOMISE (Kabuki plays)	Minami-za Theater
DEC. 21	SHIMAI KŌBŌ	Tō-ji
DEC. 25	SHIMAI TENJIN	Kitano Shrine
DEC. 31	OKERA MAIRI	Yasaka Shrine

after the Buddhas and their attendants. The mountain above Chinkō-ji is significantly named Mt. Amida, and Kiyomizu-dera Temple is built on pillars symbolizing the pillared Paradise of the Bodhisattva Kannon (an attendant of Amida embodying his mercy).

The souls in Hell rather than those in Paradise always demanded special prayers and festivals, for they were the souls of those who were unable to go "uphill" and were condemned to roam the surface of the earth, bringing disease and disaster to the world of the living. The Bon Festival addresses itself primarily to the suffering souls in Hell, which are welcomed back to earth at places that have traditionally been regarded as gates of Hell.

People observing the Bon festival, when visiting Chinkō-ji, will first ring the temple's famous bell, for the sound is believed to penetrate every corner of Hell, announcing to the souls that they are now allowed to return to the world of the living. According to a legend, the sound of the bell at Chinkō-ji once reached as far as China, where it was heard by Chinkō-ji's head priest, then on a journey. At Chinkō-ji until some years ago, people would buy a branch of pine and lower it into the well, which was considered the gate of Hell, so that the souls could take hold of it. Nowadays, however, there is no well at Chinkō-ji, so people immerse their branches in any well near their homes, sometimes leaving it there for two days to make sure that the souls have found it. Then they take the branch home and display it at the house altar or a stand (bon-dana) especially arranged for the season. After these rituals, many people invite a Buddhist priest to their homes to recite prayers for the salvation of the souls. At the same time special prayers are offered in temples.

To entertain the dead visitors, various performances are held. Nō and Kabuki plays, which often deal with suffering souls in Hell, are popular. People also gather to dance in a circle while reciting the name of Amida Buddha. Such a ceremony was formerly held at Eikan-dō Temple (near Nanzen-ji), known for its Amida statue. One day in 1081, according to legend, the priest was leading his yearly dancing group around the statue when suddenly the statue stepped down from its pedestal and joined the group. The priest, surprised to see the Buddha among the dancing people, hesitated. Amida looked back and said: "You are slow!" Such dances, called *rokusai nenbutsu odori*, are still held on the ninth and sixteenth of August at Mibu-dera Temple, and are considered the origin of the famous Bon dances that can be seen throughout Japan. These dances probably date back to the priest Kūya (903–72), a precursor of Hōnen, who taught the people to dance in a circle while chanting "Hail Amida Buddha!"

Two days later a huge ceramic market is held at Gojō Street. During the Bon season it is customary to throw away all used crockery and to buy new pieces. Potters take advantage of this fair to display their products, and on both sides of the street their wares, of all types and colors, fill the stalls. The reason for this ceramic festival at Gojō Street is not only the street's proximity to Chinkō-ji, but also because of the many kilns in that area. From as early as the seventeenth century, ceramics have been produced in the area of Gojō Street and Kiyomizu-dera Temple, hence the name Kiyomizu ware, one of the oldest and finest in Japan, for which Kyoto is particularly famous.

As at New Year's, the people of Kyoto eat special dishes during the Bon season. One of them, called *hasu-gohan*, consists of rice cooked with lotus petals. The Western Paradise of Amida is symbolized by the lotus, which grows in the many paradisial

ponds, and the custom of eating lotus rice perhaps stems from the people's wish that dead guests be reborn in Amida's Land of Bliss.

On August 16, the last day of the Bon Festival, the souls must be sent back. To guide the souls, not to Hell but uphill toward Paradise, huge fires are set at nightfall on the slopes of a number of mountains to the north, east, and west of Kyoto. The largest is at Mt. Nyoigatake in the east (also called Mt. Daimonji), a hill behind the Ginkaku-ji (Silver Pavilion). The fire is arranged in the shape of the Chinese character meaning great. The origin of this fire ritual called Daimonji (the character "great") is shrouded in mystery. Legend has it that when a temple, which once stood at the foot of the mountain burned down, the statue of Amida, the temple's main object of worship, flew to the top of the mountain, shedding light, and the fire commemorates this miracle.

In northern Kyoto a number of other fires are set on various hills. One of them burns in the shape of *myō-hō*, two characters denoting the Buddhist concept of Wonderful Law, a reference to the *Lotus Sutra*. Another has the shape of a boat. People believe that this represents the boat on which a ninth-century Japanese priest made a safe voyage to China, but another tradition has it that it is the boat on which souls return to the other world. Yet another fire burns in the form of the gate of a Shinto shrine, representing entry into sacred territory. Here it probably designates entry into Paradise. Opposite Mt. Daimonji, in the west burns a second fire in the shape of the character "great," which is set just north of Kinkaku-ji, the Golden Pavilion.

On the same day many Buddhist priests of temples in and around Arashiyama gather at Togetsu-kyō Bridge (famous since Heian times) to offer prayers. After that they launch a number of paper lanterns lit with candles down Katsura River, symbolizing the return of the souls, this time not to the mountains but to the sea, believed to be another haven of the dead. People also make small boats out of leaves, place in them all the foods offered to the souls during the Bon Festival as well as the utensils used to cook the food (a Shinto taboo demands the disposal of all objects that come into contact with the dead), and float them downriver.

ARTS AND CRAFTS

Ever since its founding Kyoto's position as the cultural center of the nation has made it a mecca for artists and craftsmen. The prominence of Chinese influence in the early Heian period saw the introduction of such arts as lacquerware, damascene, and weaving from China. With the development of such Japanese art forms as the tea ceremony and flower arrangement, attendant arts and crafts like pottery and the making of bamboo utensils flourished in the city. In the seventeenth century Nō drama was at its height, and its elaborate costumes inspired a revival in the art of weaving. Other crafts with which Kyoto has become synonymous are doll making, fan making and woodblock printing. Each of these crafts is worth a separate volume, but as one of the oldest— weaving and dyeing—has had the greatest economic and cultural effect on Kyoto, it is this we will examine in detail.

Even before the Heian capital was established, Kyoto was a silk weaving area, and by Heian times silk weavers were active in the area roughly east of present Ōmiya. Many of these seem to have been members of immigrant families who came either from

Korea or China, bringing with them advanced techniques of silk production and weaving. There stands as a reminder of those days the Kaiko no Yashiro, a shrine established to honor silkworms, not far from Kōryū-ji, a temple erected by an immigrant family.

In the Muromachi period (1338–1573) members of various trades organized themselves into guilds, which were protected by the military government, and no one outside a guild was allowed either to produce or sell. The weavers formed one of the most powerful guilds, and along with rich merchants and other artisans like themselves, they rebuilt part of the city, especially the southern quarter, after it had been destroyed in the 1467–77 civil wars. The merchants, however, did not preserve the old Heian city plan: they abolished the old city divisions of *jō* and created *machi*, or blocks. Naturally, they structured the blocks around the various guilds, and the city thus came to be divided into occupationally specialized districts.

In the aftermath of that destructive period between 1467 and 1477, the weavers found the vast empty fields once fought over by warring armies an appropriate place to expand their industry. The area of Nishijin (Western Army Camp) and Higashijin (Eastern Army Camp) came to be occupied by weavers. The Nishijin, however, gained an edge over the Higashijin when it won monopoly rights to textile production, and the boom in weaving at Nishijin that began in the sixteenth century, despite various recessions, has flourished right up to the present. Nō costumes made in the sixteenth century reveal the splendid level of workmanship Nishijin weavers had attained by that time—in gold brocade, damask, satin, thin silk, crepe, and velvet. The advent of new mechanized looms allowed far more elaborate designs, and luxurious robes came to be worn not only by actors and dancers but also by warriors and wealthy merchants at festivals, weddings, and tea ceremonies. Appropriately enough, Nishijin weaving prospered even more under Toyotomi Hideyoshi, who had a taste for luxurious fabrics, and by the end of the seventeenth century, weaving reached unprecedented heights. Kabuki and puppet theaters flourished during this period, and about one thousand looms and as many as five thousand weavers produced goods that were distributed throughout the country. Some of the leading artists of the period were engaged in textile design, like Ogata Kōrin (1658–1716), a famous painter, who is remembered for his grass and flower designs, bold yet refined irises, and red and white plum blossoms.

Nishijin survived hard times in the eighteenth century, such as disastrous fires in 1730 and 1788, to recover and progress in the nineteenth. After the Meiji Restoration of 1868, government funds helped modernize the industry and machinery from Europe made weaving successful, dispelling fears that Kyoto would stay a sleepy historical town without a modern economy.

Today about sixteen hundred weavers are left in the Nishijin area of Kyoto. Large parts of the district have changed little since the fifteenth and sixteenth centuries: the typical house of a weaver is narrow at the street side because merchants were formerly taxed not according to production or revenue but according to the frontage their houses occupied on the street. To compensate for their narrowness, the houses extended back a great distance. The looms would usually be at the rear to mask the rattling noise, and probably also to hide the hectic rate of production from the tax collectors.

CHRONOLOGY OF JAPANESE HISTORY

ca. 7,000–250 B.C. Jōmon pottery culture

ca. 250 B.C.–A.D. 250 Yayoi culture

YAMATO PERIOD (ca. A.D. 300–645)

552 Introduction of Buddhism from China

593–622 Regency of Prince Shōtoku (Shōtoku Taishi)

607 First major embassy to China

645–50 Taika Reform

NARA PERIOD (710–784)

710 Nara becomes Japan's first permanent capital

752 Dedication of Great Buddha of Tōdai-ji, Nara

781–806 Reign of Emperor Kammu

784 Kammu abandons Nara for Nagaoka

HEIAN PERIOD (794–1185)

794 Kammu abandons Nagaoka for Kyoto (Heian-kyō)

805 Introduction of Tendai sect by Saichō (767–822)

806 Introduction of Shingon sect by Kūkai (Kōbō Daishi) (774–835)

823 Tō-ji Temple founded by Kūkai

838 Twelfth and last embassy to T'ang China

995–1027 Supremacy of Fujiwara no Michinaga

ca. 1002 Sei Shōnagon writes *The Pillow Book*, a diary of Heian court life

ca. 1008 Murasaki Shikibu writes *The Tale of Genji*

1159 Heiji War

1160 Taira no Kiyomori emerges as undisputed leader

1175 Introduction of Jōdo (Pure Land) sect by Hōnen (1133–1212)

1180–85 Gempei War between the Minamoto and the Taira clans, won by the Minamoto

KAMAKURA PERIOD (1185–1333)

1191 The priest Eisen returns from China and founds the Zen sect

1192 Title of shogun granted to Minamoto no Yoritomo

1274 First Mongol invasion

1281 Second Mongol invasion

1336 Emperor Godaigo (1288–1338) banished by Ashikaga no Takauji (1305–58) to Yoshino

MUROMACHI PERIOD (1338–1573)

ca. 1360–1400 Nō drama flourishes through Kan'ami (1333–84) and Zeami (1363–1444)

1368–1394 Ashikaga no Yoshimitsu (1358–1408), third shogun

1392 Reunion of Northern and Southern Courts

1397 Kinkaku-ji (Golden Pavilion) built by Yoshimitsu